1980s
FASHION PRINT

1980s
FASHION PRINT

marnie fogg

BATSFORD

To a dear friend, Frank McEwan, 1957–1992

First published in the United Kingdom in 2009 by
Batsford
10 Southcombe Street
London
W14 0RA

An imprint of Anova Books Company Ltd

ISBN: 978 19063 8841 6

A CIP catalogue record for this book is available from the British Library.

17 16 15 14 13 12 11 10 09
10 9 8 7 6 5 4 3 2 1

Reproduction by Spectrum Colour, UK
Printed by Imago, Singapore

This book can be ordered direct from the publisher at the website
www.anovabooks.com, or try your local bookshop.

Distributed in the United States and Canada by Sterling Publishing Co.,
387 Park Avenue South, New York, NY 10016, USA

Title page: 'Pow', from the 'Wave'
collection by Alexander Henry Fabrics.

CONTENTS

INTRODUCTION

The fashion prints of the 1980s were not for the faint-hearted. It was a decade that celebrated excess, from the outrageous fancy dress of the British New Romantics to the über-glamour of Gianni Versace's opulent Mannerist prints for the super-rich. In America, Ronald Reagan was inaugurated as president; his high-maintenance wife, Nancy, ensured that the 'occasion dress' by American designers such as Oscar de la Renta and Bill Blass had plenty of outings. Supermodels replaced Hollywood stars in the glamour stakes, and popular soap operas such as *Dallas* and *Dynasty* portrayed the fantasy lifestyle of wealthy Americans: it was an era of 'pay and display'.

Such ostentation was in marked contrast to the previous decade. The 1980s saw fashion make a comeback from the recession-hit 1970s, when haute couture had only an ageing clientele and the burgeoning feminist movement considered any attire that wasn't 'trousered anonymity' to be pointlessly frivolous. By the beginning of the decade, the youthquake led by Mary Quant in the 1960s had long ago lost its appeal, hippie chic and Woodstock were a distant memory and the recent punk movement had foundered on a wave of commercialism: it was time for change.

Right: The summer 1985 collection of the design group The Cloth, displayed in the windows of the London store Liberty. Photograph by Anita Corbin.

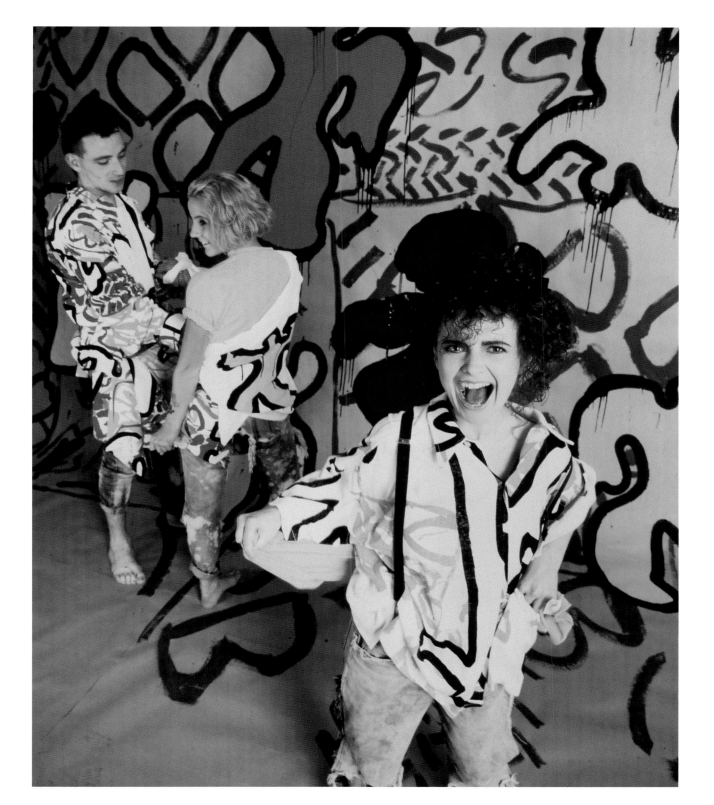

The 1980s saw a seismic shift in attitudes towards fashion: it was an era of conspicuous consumption and fashion became fashionable again. The immense strength of the American dollar from 1980 to 1985 meant that there was a new clientele for haute couture. Karl Lagerfeld rejuvenated the House of Chanel, and in 1987 optimism was such that Christian Lacroix established a new couture house.

When Margaret Thatcher became Britain's first female prime minister in 1979, the relationship between power and gender was debated at the highest levels. Increasing numbers of women began to enter that bastion of male power, the boardroom, and the self-effacing cardigan or droopy maxi-skirt just wasn't going to cut it. The new conservatism that emerged as the female baby boomers found themselves in well-paid jobs was matched by a new, sharply defined silhouette in strong colours and vibrant prints.

A new breed emerged – the yuppie. These 'young, upwardly mobile professionals', satirized by American journalist Tom Wolfe in his 1987 novel *The Bonfire of the Vanities,* lived and worked in the financial capitals of the world. There was a new seriousness about being successful, and appearances reflected this; the corporate world saw the idealization of the fashion label and the emergence of the big brand. Fashion empires were created by Ralph Lauren and Calvin Klein in America, and by Gianni Versace and Giorgio Armani in Italy. As Nicholas Coleridge wrote in his book, *The Fashion Conspiracy*: 'The decade from 1978 has been decisive for fashion, as important as the 1950s were for the motor industry and the 1970s for computers. Designers like Ralph Lauren, Calvin Klein and Giorgio Armani have created from nothing fashion empires on a scale and with a speed that seemed impossible in the mid-1970s … This has produced a compelling new factor in the world economy: designer money.' [1]

A more subversive narrative was unfolding in London. Magazines such as *i-D*, *The Face* and *Blitz* commodified street culture and its mix of dance, music and fashion, featuring the work of British designers such as Bodymap and English Eccentrics. The 1980s was the start of a period of creativity that was to make London the hub of wild and iconoclastic fashion ideas. The New Romantics, a post-punk subculture, subverted the notion of glamour into an excessive display that was pure masquerade, born out of the dressing-up box and relying on a singular appreciation of the eclectic. British designer Vivienne Westwood pursued this aesthetic with 'Pirate', her first collection under her own name. In contrast to the sharp and fitted silhouette then seen on the pages of *Vogue*, the collection referenced a Hollywood version of the high seas buccaneer through the medium of African-inspired colours and serpentine prints.

The work of British designers such as members of a group collectively known as The Cloth, and Hilde Smith for Bodymap, were instrumental in London being seen as the hub of the avant-garde in textiles, as well as in fashion. In 1983, the influential American trade paper *Women's Wear Daily* commented in their article 'England's Fabric' on 'the humour, the willingness to take risks, the unexpectedness and the eccentricity that only the British can deliver. London offers new directions'. These new directions were not fuelled by technical innovation – digital printing was not yet an option – but by the relatively new phenomenon of the designer/manufacturer producing work from his or her own craft-based studio. Despairing of an industry afraid of innovation and the avant-garde, textile designers explored new ways to manufacture and distribute their own products. These designer-entrepreneurs, such as The Cloth, pursued the artisanal

1. Coleridge, Nicholas (1988). *The Fashion Conspiracy: A Remarkable Journey Through the Empires of Fashion*. London: William Heinemann Ltd., p. 4.

Left: From the Gaudi collection by Helen David of English Eccentrics, 1985.

Above: A mixed-media design by Furphy Simpson printed on very dark navy crepe de chine. The floral images, which came from the designer's collection of antique flower books, were enlarged and then reduced to half-tone using photocopying techniques: this was before the use of computers.

tradition by setting up small-scale workshops and communities, their design practice resolutely rooted in fine art and including graphic design, illustration and textile design. The design studio Furphy Simpson, a partnership formed when Val Furphy and Ian Simpson both graduated from London's Royal College of Art in 1976, initially designed and printed fabrics for various London-based fashion designers. They went on to produce their own collections that sold, and continue to sell, to customers in New York, Paris, Japan and London. Contemporary clients include Etro, the relaunched Ossie Clark label and the Kate Moss collection for British retailer Topshop.

Italian designers were already familiar with the infrastructure of the craft-based workshop; following the Second World War, the country had undergone a period of unparalleled economic and cultural change abetted by massive economic aid from the

United States. This regeneration established Italian design as a brand with an enviable reputation for quality of craftsmanship, and in the 1980s this was allied to one of the most provocative and influential design movements of the era. The design group Memphis, founded by Italian architect Ettore Sottsass in 1981, dominated the design scene with its post-modernist style. Named after the Bob Dylan song 'Stuck Inside of Mobile With the Memphis Blues Again', it was a reaction to the Bauhaus precept of 'Form follows function', which denied the purely decorative. Taking images from an eclectic multiplicity of sources – Art Deco, 1960s pop culture and 1950s kitsch, Memphis celebrated the surface with strident colour and dissonant pattern, breaking the rules and discarding preconceived ideas of what constituted 'good taste'. In textile terms, this meant the energetic, vibrant, almost kinetic work of the French designer Nathalie du Pasquier.

The 1980s became known as the 'designer decade' as increasing numbers of consumers bought into the concept of lifestyle marketing, a phenomenon eagerly exploited by the emerging fashion and interiors brands. Design began to be perceived as a service industry, rather than as a creative process. Used as a marketing prefix, it was deployed to sell everything from cars to cutlery.

Innovation in print design was spearheaded for the first time by designers of fashion fabrics, rather than by designers of interiors. This was a result of the developing awareness of fashion's role in a newly expanding consumer culture, which led to a greater acceleration of trends. Print design for the home was dominated by period revivals as manufacturers sourced designs from their archive of document prints.

The 'New Money' appropriated the English country-house style, a throwback to the eighteenth century but with everything new – a look that style guru Peter York described as

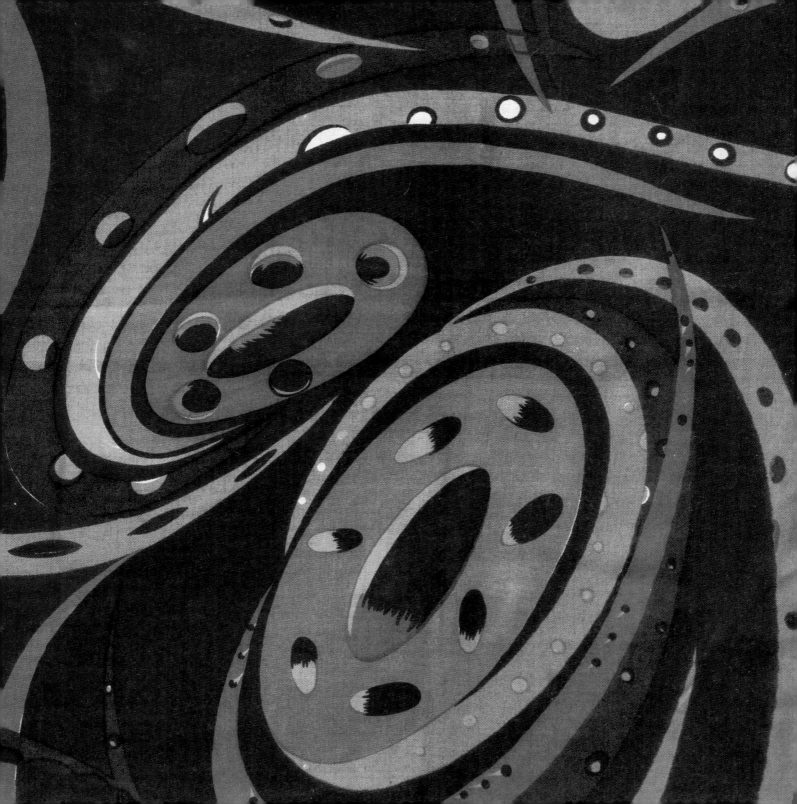

Left: In this design, *Tempest*, Georgina von Etzdorf combined her use of velvet with the decorative printing technique process of devoré, a French word meaning 'to devour'. The process uses a chemical gel to dissolve cellulose fibres such as rayon and viscose without harming the non-plant silk fibres: areas of pile on rayon velvet are burnt away with acid printing to leave shadows of silk chiffon amid the remaining deep pile.

'a lurid Gainsborough video of posh English past'.[2] No 'shabby chic' here: it was an aspirational, aristocratic look that crossed the ocean to America. The British company Warner, under the aegis of Eddie Squires, produced the 'Stately Homes' collection in 1982, including such patterns as *Marble Hall*. The *trompe l'oeil* effects of traditional decorative accessories such as *passementerie* appeared in both fashion and interior prints, such as *London Tassels* by Mandy Martin in 1987. Fabrics were ornate and highly coloured, very often featuring large floral bouquets and twisting scroll forms. These varnished chintzes and large-scale repeats were manipulated into extravagant and over-the-top swagged and ruched interiors, where everything matched and designs came in complete sets: wallpapers, borders, curtains and bedlinen.

Although the decade is remembered for its celebration of excess, whether in the width of a shoulder pad or in lavish and ostentatious patterning, it was also an era of unparalleled creativity, which permeated all aspects of the visual culture of the time and the influence of which is still felt today. A flourishing financial climate perpetuated the idea of conspicuous consumption and extravagant display, yet it also allowed for its opposite, the promulgation of a lively, yet serious, investigation into a personal creativity which could then be disseminated by the new media.

2. York, Peter (1984). *Modern Times*. London: William Heinemann Ltd., p. 23.

1 NEON BLITZ

London, in the 1980s, was at the centre of iconoclastic fashion and textile ideas. This was the result of the unique curriculum of British art and design education, which was firmly rooted in the contextualization of design within a fine art framework and which encouraged creativity to its limit. The graduate and postgraduate fashion shows of the London colleges, particularly those of Central Saint Martins and the Royal College of Art, attracted buyers and press from all the major fashion centres of the world. Together with the London club scene, where fashion met music and performance art, Britain's capital resonated with a sudden explosion of flamboyant creativity, which attracted even established designers such as Jean-Paul Gaultier and Issey Miyake, both of whom visited the city in search of inspiration.

Style magazines such as *i-D* and *The Face*, initially punk fanzines, reported these cultural changes, experimenting with new graphic styles and subverting the notion of the glossy fashion magazine by using grainy shots taken from videos and Polaroids, with distorted text and handwritten headings. The founder of *i-D*, Terry Jones, called these photographs of real people wearing real clothes 'straight-ups' – a social documentation of a generation dressing itself. The 1980s was

Right: The dramatic shapes and the adjoining vibrant colours provide an intensely abstract experience in this painterly design by Liberty.

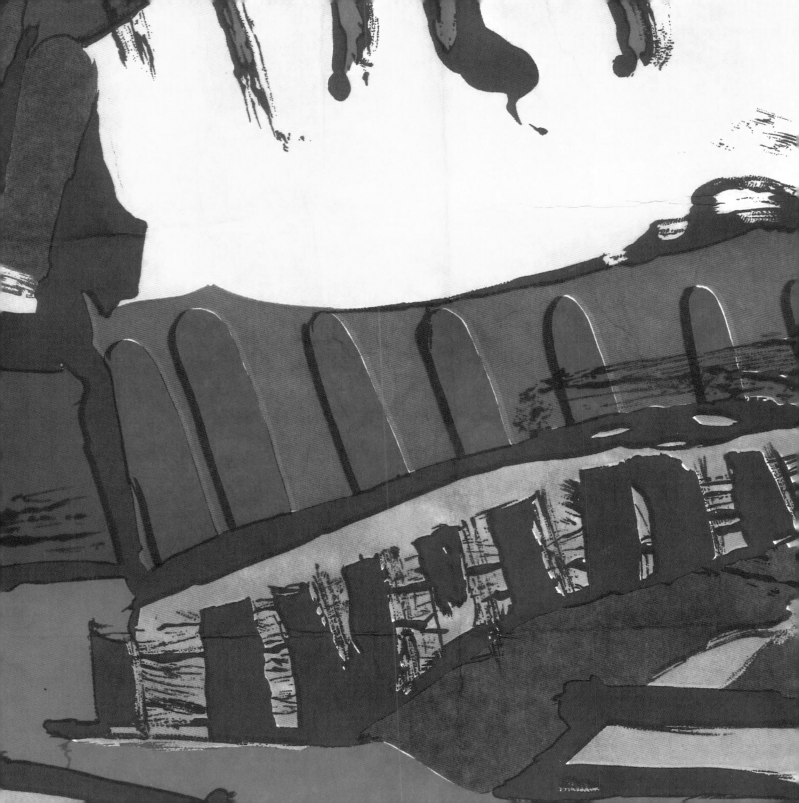

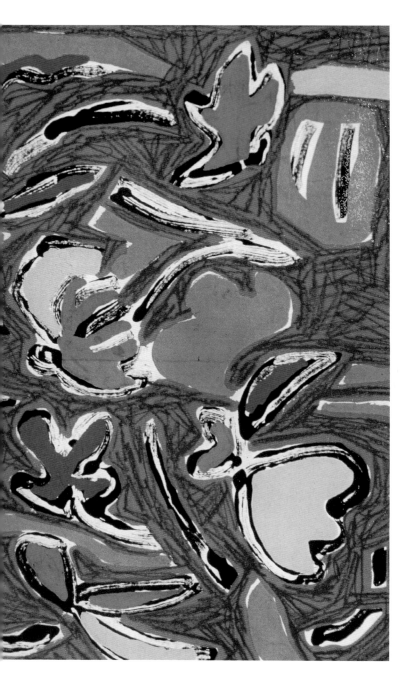

a decade obsessed with the concept of style, and Nick Logan's *The Face*, under the art director Neville Brody, became the most influential design magazine of the era. Its pages recorded the idiosyncratic, home-made couture of street style and celebrated the cult of the individual.

The ethos of the New Romantics, a youth subculture who clubbed at the Blitz and Taboo with Leigh Bowery (the artist Lucian Freud's muse and model), was customization rather than commoditization. They displayed an extravagant and excessive preoccupation with personal style, epitomized by members of two British bands: Culture Club's lead singer Boy George, and Steve Strange of Visage. Between 1979 and 1987, fashionable nightclubs witnessed a parade of costume changes – from the radical aesthetic of Vivienne Westwood, to the cartoon juxtaposition of eye-catching prints and knits of the British design label Bodymap.

Bodymap was formed by two Middlesex College of Art students, Stevie Stewart and David Holah, in 1982. A fusion of easy-to-wear fabrics cut close to the body, with innovative seaming exposing unexpected areas of flesh, was unique to the label. The layers of woven and knitted patterned fabrics were mediated through diverse and whimsical juxtapositions of narrative. The 'Cat in a Hat Takes a Rumble with a Techno Fish' collection of 1984 effectively used the black-and-white, hard-edged print designs of textile artist Hilde Smith. 'Barbie Takes a Trip Around Nature's Cosmic Curves' utilized synthetic fabrics, Day-Glo colours and bizarre prints.

Left: Abstract areas of flat colour float on a freely scribbled backdrop. By Fraser Taylor of design group The Cloth, 1985.

Right: Artwork for a Liberty print design. Geometric pieces of tissue paper are overlaid with painted and printed marks, then directly described onto the cloth by the screen-printing process.

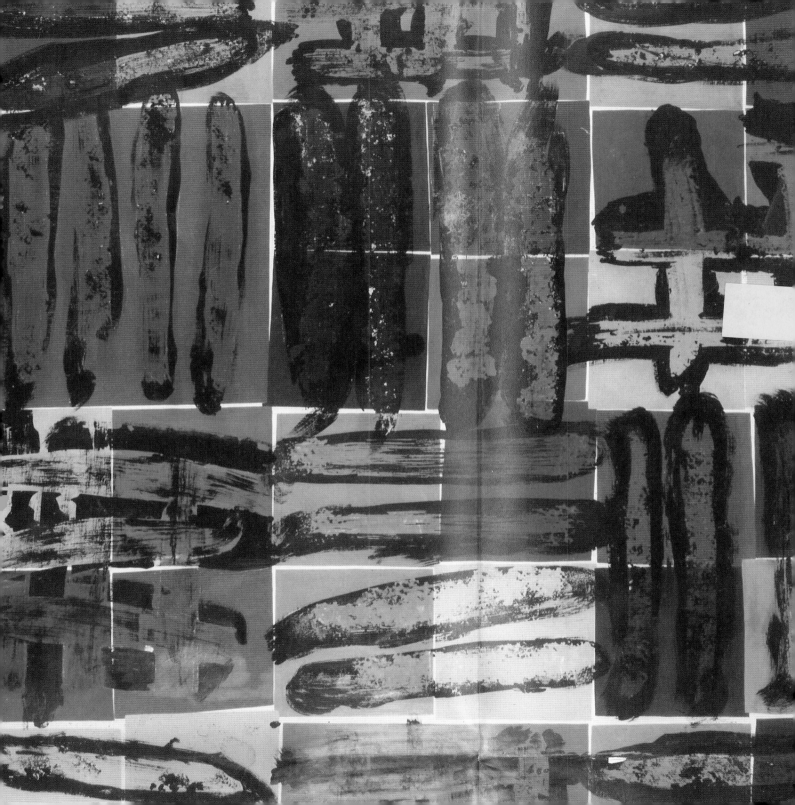

Left: Typical of British textile designer Hilde Smith's work, *Cosmic Check* is a monochrome play on tartan. Designed for Bodymap's 1985 collection, 'Barbie Takes a Trip Around Nature's Cosmic Curves'.

Vivienne Westwood's aesthetic of historical revivalism took its inspiration from culture rather than street style. Eager to disassociate herself from the 1970s punk movement initiated by herself and her then partner Malcolm McLaren, Westwood produced a fashion collection in 1981 called 'Clothes for Heroes'. The 'Pirate' collection, a synthesis of ideas drawn from such diverse sources as English seventeenth- and eighteenth-century tailoring and African prints, ultimately presaged the 'pirating' of ideas by the New Romantic movement. This plundering of other cultures surfaced in further collections: Aztec and Mexican patterns and motifs provided inspiration for the print design and colouration of 'Savage' in 1981, and Appalachian folk culture in the 'Buffalo' collection of 1982. 'These clothes are searching for the primitive,' she told *Vogue* in 1981. [1]

Parallel to Vivienne Westwood and Malcolm McLaren's promulgation of punk in London, Stephen Sprouse was energizing the New York scene with his compelling version of the relationship between art, rock music and fashion. In 1984, after several years' experience with Halston, the designer darling of the 1970s disco scene, Sprouse introduced his first influential collection from his silver-plated showroom on New York's 57th Street. An obsessive draughtsman from infancy, and an avid purveyor of the visual ephemera of contemporary urban life, Sprouse incorporated a synthesis of 1960s and 1980s pop and street culture into his work. Graffiti, once the subversive activity of disaffected youth, became accepted as a legitimate art form, and alongside practitioners Jean-Michel Basquiat and Keith Haring, Sprouse appropriated the tags and stencils of the street and added Day-Glo colours in rayon, velvet and satin.

The relationship between art and fashion was also explored by a British design group, The Cloth. All graduates of the printed textiles department at London's Royal College of Art, Fraser Taylor, Helen Manning, David Band and Brian Bolger formed

Above: The textile designs of Hilde Smith are inextricably linked to the fashion aesthetic of the British design duo Bodymap. Printed in black and white on knitted viscose sweatshirt fabric, these designs were two of the 'Big Mesh' collection produced in 1984.

1. Vivienne Westwood, quoted in *Vogue*, April 1981, p.46.

their interdisciplinary design studio in 1983 to facilitate the movement between art and design projects. In contrast to the prevailing post-modern ethos, their practice was not to 'borrow' motifs, but to rely on the fluidity and expressiveness of the drawn and painted mark, using their fine-art background to inform the creative process, whether for fashion, textile or graphic design. Drawing from life reinforced the group's interest in the human form both as a source and a device to explore formal concerns and mark-making techniques. As Fraser Taylor explains: 'We believed strongly that personally developed visual research was vital in enabling us to achieve innovative images.' Sources also included both natural and urban landscapes, graffiti, the Greek, Roman and Egyptian galleries of the British Museum, and partially demolished buildings that exposed fragments of domestic interiors. All were transmuted into printed textile design by the power of hand drawing and the brushstroke, rather than the photographic image. Artists under continual scrutiny by the group were Henri Matisse, Jean Dubuffet, Keith Haring, Jean-Michel Basquiat and Cy Twombly, all of whom shared a common interest in colour, the fluidity of paint, evidence of the artist's hand and the intentional avoidance of perspective, resulting in a flattened picture plane.

Right: Diverse influences, such as the graphic style of Keith Haring and the imagery found in the work of the post-Impressionist artist Matisse, can be seen in this still life of T-shirt designs by The Cloth. Photographed for *Blitz* magazine in summer 1984, and styled by Iain R. Webb.

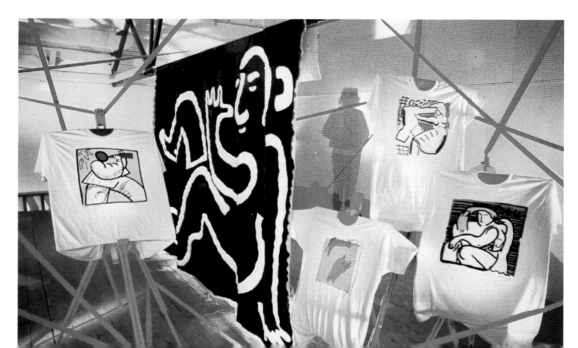

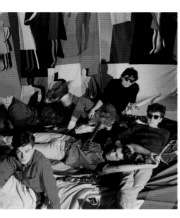

Above: Art and music collide in this promotional photograph of Scottish pop group The Bluebells, posed in front of a printed backdrop by Fraser Taylor of The Cloth in 1983.

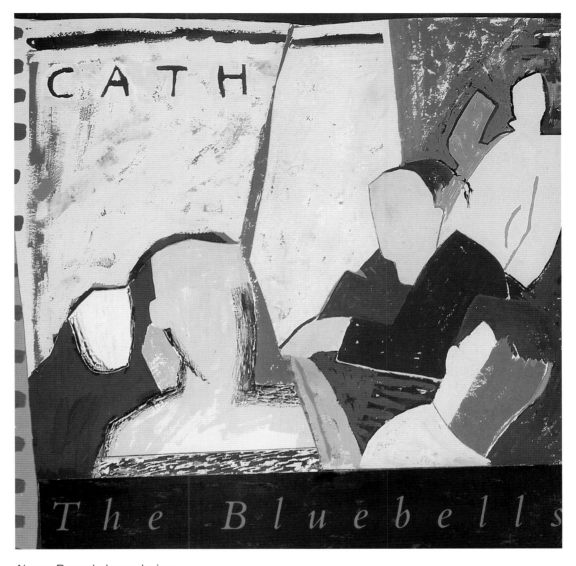

Above: Record-sleeve design utilizing overlaid pastels, collage, paint and pen and ink, by Fraser Taylor of The Cloth for The Bluebells' hit single, 'Cath', produced in 1983.

Exploration of varying and combined scale was also pivotal in enabling the group to visualize their designs as textiles, graphics, illustrations, large-scale mural commissions and projects in exhibition and stage design. Some of their earliest textile commissions, for designers such as Betty Jackson, contained repeat structures of anything up to two metres long, resulting in the printed length being cut up and reassembled to produce a garment which further obscured the repeat, abstracting the image even more. As Taylor confirms, 'The styles of the fashions from the early to mid-1980s were very extreme, with dramatic shoulder pads and oversized silhouettes, thus providing a large, canvas-like area to print expressive, brightly coloured marks.' Clients also included Paul Smith, Yves Saint Laurent, Bill Blass and Calvin Klein.

At the beginning of the 1980s, the Swedish design group Tio-Gruppen (Ten Swedish Designers) had already been established for ten years. A decade earlier, the group of textile artists, disaffected with current practices and seeking greater opportunity to promote their own ideas, joined together with the intention of taking control of the entire production process of textile design, from the initial artwork to displaying the fabric in a shop. The collective was formed by Gunilla Axén, Susanne Grundell, Lotta Hagerman, Birgitta Hahn, Ingela Håkansson, Tom Hedqvist, Carl Johan De Geer, Britt-Marie Christofferson, Tage Möller and Inez Svenson. Predating the Italian design group Memphis and their iconoclastic post-modern approach to pattern, the group created a series of textile collections throughout the 1980s that resonated with energy and colour and challenged traditional pattern-making conventions.

Right: A monoprint from Val Furphy and Ian Simpson of design studio Furphy Simpson. The base is dark brown crepe de Chine, a fabric much favoured by the design duo for the discharge printing process.

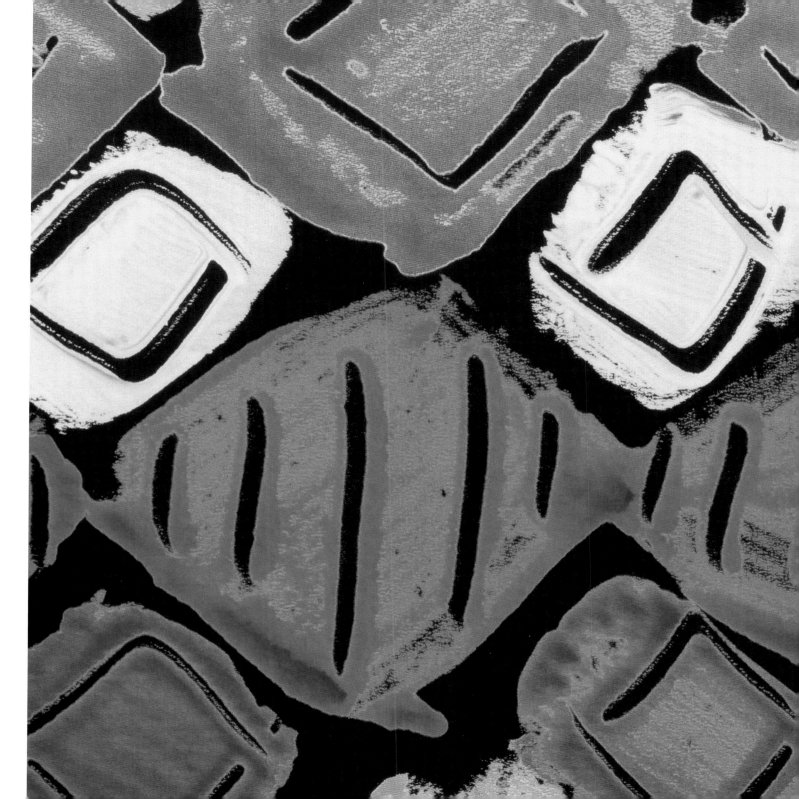

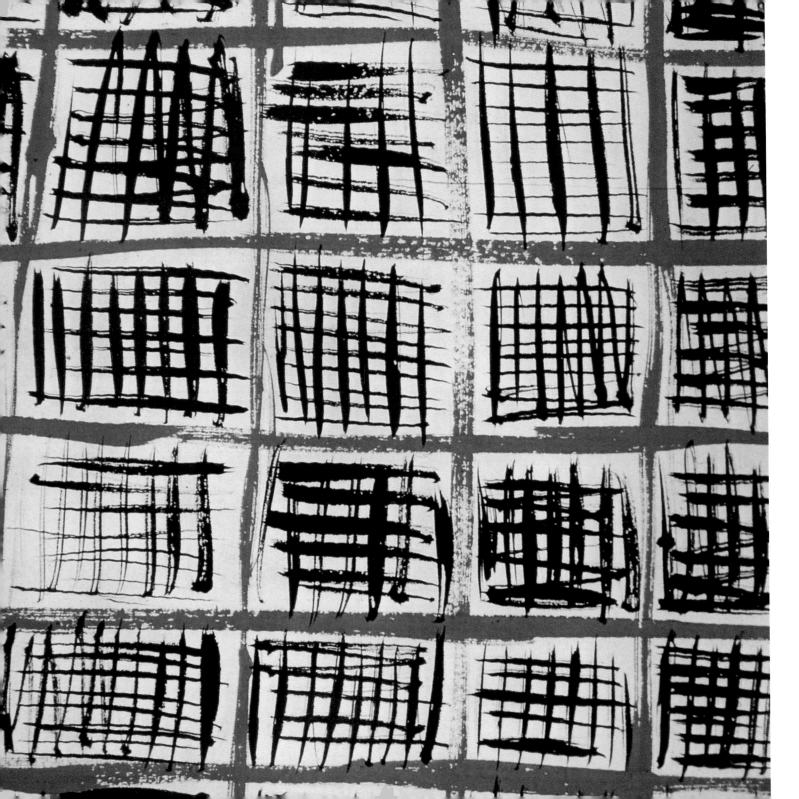

Left: Deceptively casual mark-making within a structured grid, in this print design by Brian Bolger of The Cloth, 1985.

Right: A three-colour screen-print design by Liberty. The broken stripes are patterned with brushstrokes of bleached-out areas on an inked background.

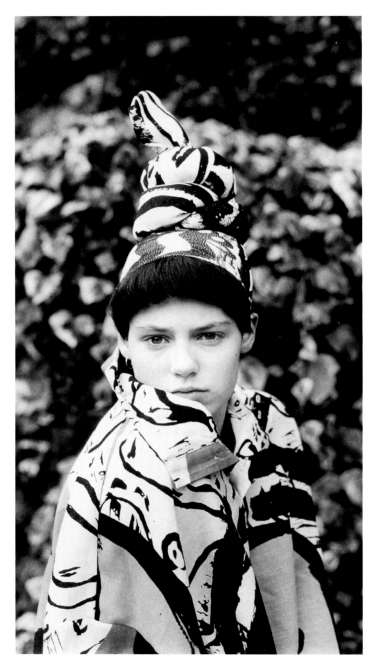

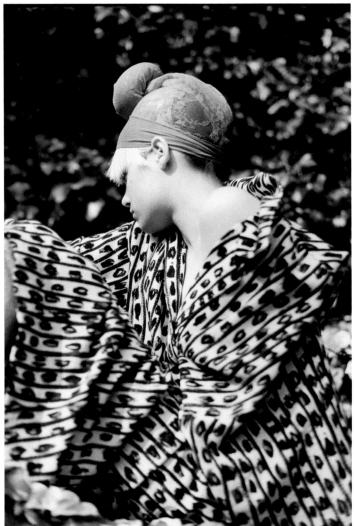

Left and above: Monotone
single-screen designs in
wool for the collection 'Log
and Loggerie' by The Cloth
for winter 1985.

Above: The traditional structure of the shirt is disguised by the painterly quality of the print in this design by The Cloth.

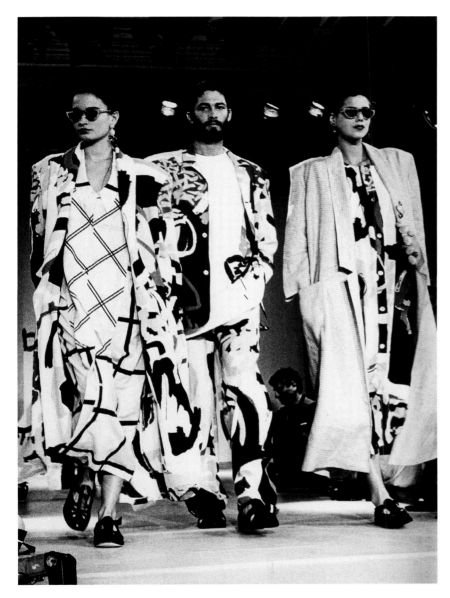

Above: The 'English Rose' print collection, designed in 1985 by Brian Bolger of The Cloth for British fashion designer Betty Jackson. The large repeat structure of the print design enhances the overall effect of the spontaneity of loose, painterly marks against the formality of the checked garments beneath.

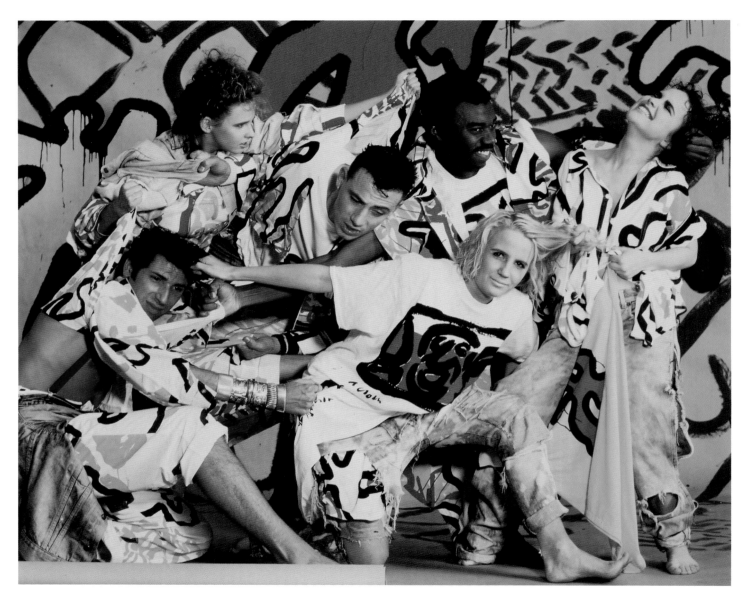

Above: The Cloth created backdrops for the windows of Liberty of London as a showcase for their summer 1985 collection, 'Summer Simmitts'. The T-shirts, shirts and shorts, printed in bright colours on white cotton jersey, were displayed in the store alongside an exhibition of paintings from the group. Photographed by Anita Corbin.

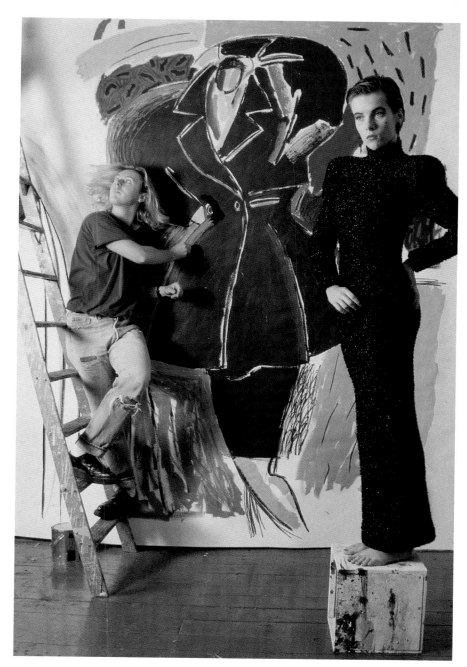

Right: Fraser Taylor, of design group The Cloth, at work on an illustration for *Blitz* magazine. Photographed by Jonathan Postal and styled by Iain R. Webb.

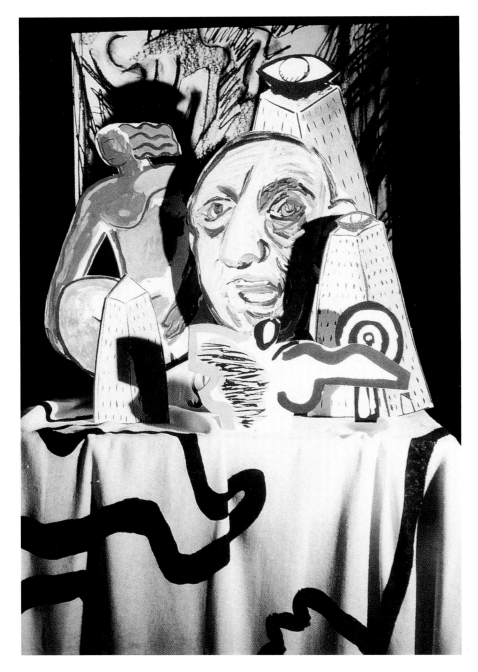

Above: The invitation to The Cloth's post-graduate show at the Royal College of Art, 1983.

Left: Still life created by Fraser Taylor of The Cloth in 1985: a combination of figurative images from life and sculptures in mixed media including gouache, acrylic and charcoal.

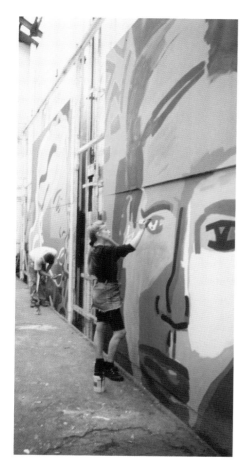

Above: Painting the set for Fabrex in 1987, the largest dress-fabric trade show in the UK.

Right: A close-up of the mural designed by Brian Bolger for Fabrex, 1987. The work utilizes the Fauvist colour palette and expressive brushstrokes typical of designs by The Cloth.

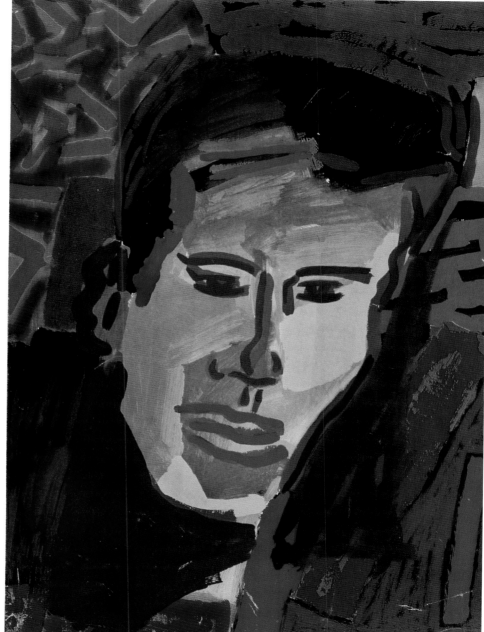

Left: A single-screen print design from Vivienne Westwood's first independent range in 1981, 'Pirates'. The collection utilized a palette of African-inspired colours and a serpentine, undulating motif often seen in the eighteenth and early nineteenth centuries.

Right: A mixed-media exercise in paint, collaged paper and felt-tipped pens comes together with fragmented areas of pattern in this eleven-colour screen-print design by Liberty.

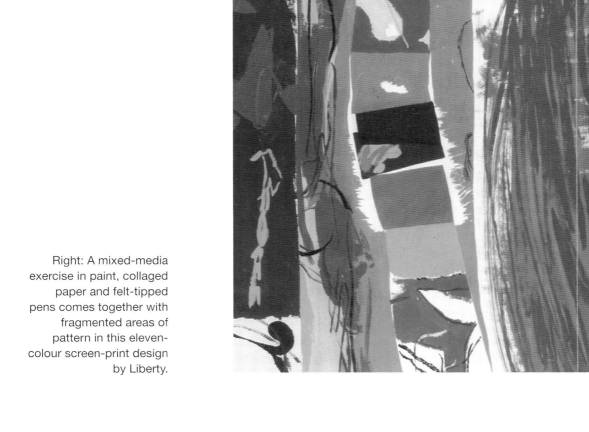

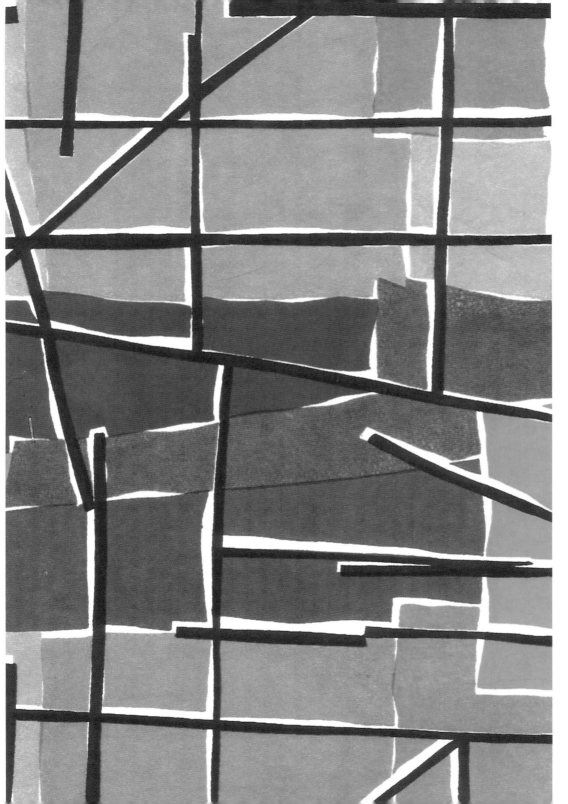

Left: Collaged tissue paper in the original artwork provides the transparency in this print by Liberty. The boundaries between the eight colours are scrupulously observed, with no overlapping of colour, and are divided by a strong, fragmented line, emphasized by the narrow white margins.

Ties, from top to bottom:

Abstract forms overprinted on floral brocade provide a striking juxtaposition in this tie by Parisian couturier Yves Saint Laurent.

A new international style was created in 1981 by Ettore Sottsass, the founder of Memphis, a group of Italian architects and designers. Their unconventional and quirky utilization of pattern, colour, form and texture proved enormously influential.

That most conventional item of men's attire, the necktie, given the Stephen Sprouse treatment in this one-colour discharge print.

The Italian knitwear company Missoni originally specialized in polychromatic, warp-knit stripes. Now a global fashion dynasty, their aesthetic embraces all aspects of pattern and garment design.

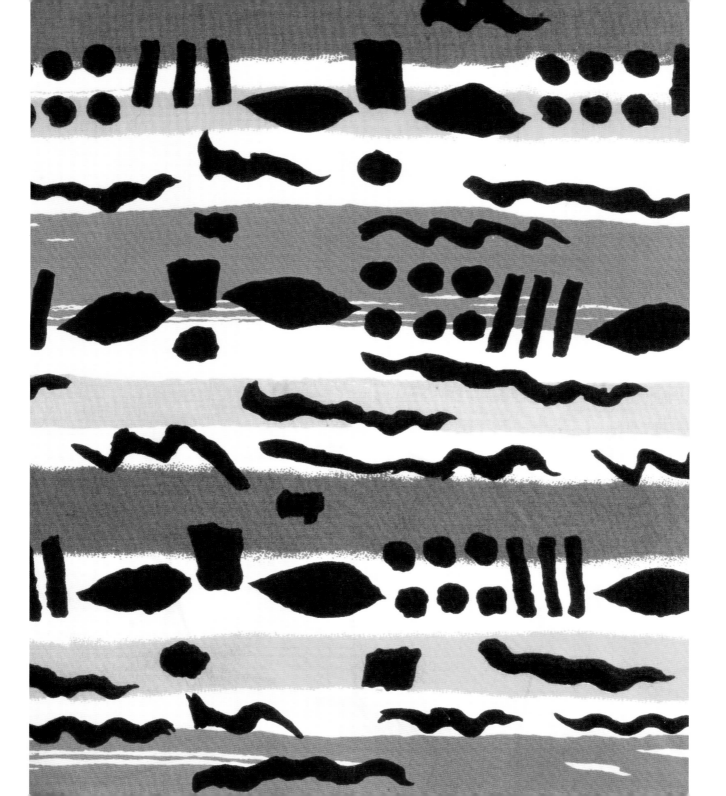

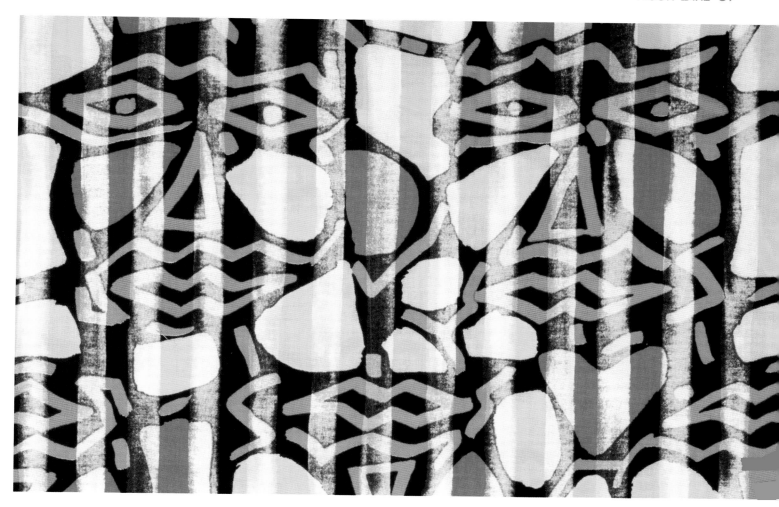

Left: A design by Furphy Simpson for the American label Williwear, composed of dyes painted onto paper and then overlaid with black pen and ink.

Above: Design by Furphy Simpson purchased by the Austrian printer Rhomberg and used by the British retailer Next Menswear. The stripes were formed by applying bleach over the painted blocks of colour on the background.

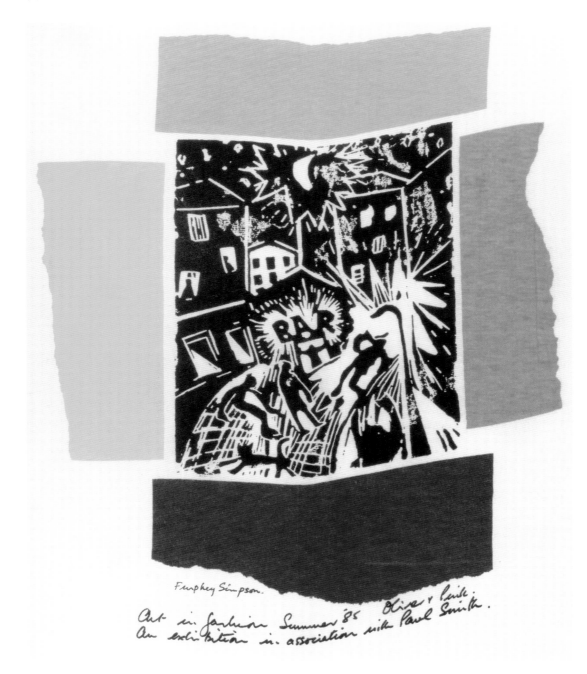

Furphey Simpson.

Art in fashion Summer 85 Oliva & Pink.
An exhibition in association with Paul Smith.

Left: A T-shirt design by Furphy Simpson for British retailer and designer Paul Smith, for a joint exhibition called 'Art in Fashion' at the Oliver and Pink Gallery in 1985. The design was influenced by the woodcuts of Frans Masereel and utilized collaged torn paper to provide a frame for the monochrome linocut.

Right: Val Furphy, of design partnership Furphy Simpson, cites American abstract-expressionist painter Robert Rauschenberg as an influence, evidenced in this mixed-media print design that combines discharge printing with photographic techniques.

Left: A Furphy Simpson design for Parisian couturier Karl Lagerfeld's first collection after leaving the French design label Chloé. The pen-and-ink and coloured cut-paper motifs were influenced by the Surrealist artist Victor Brauner. This design was printed with colour discharge out of black silk.

Right: A pencil doodle was the inspiration for this colour discharge print out of black silk, for Italian label Cerruti, by Furphy Simpson.

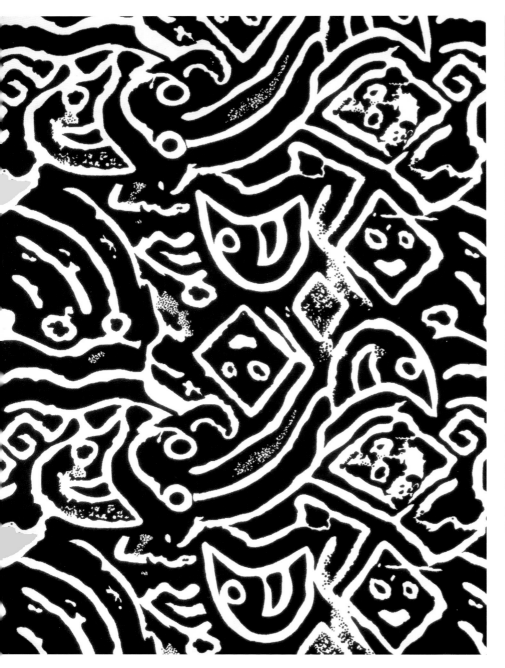

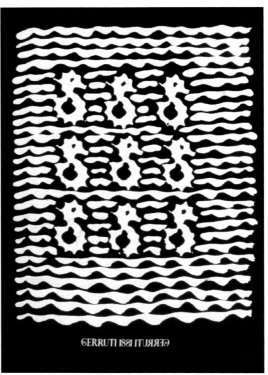

GERRUTI 1881 ITURRƎƏ

Above: The simple but effective technique of potato printing, a process still deployed by the design duo Furphy Simpson, forms the monochrome design of seahorses on brushstroked waves on this T-shirt for the Italian label Cerruti 1881.

Left: A black-and-white linocut design by Furphy Simpson for Williwear.

Right: A linocut design by Furphy Simpson, featuring a tattooed bird in the hand. Originally in black and white, it was recoloured by the American design label Williwear.

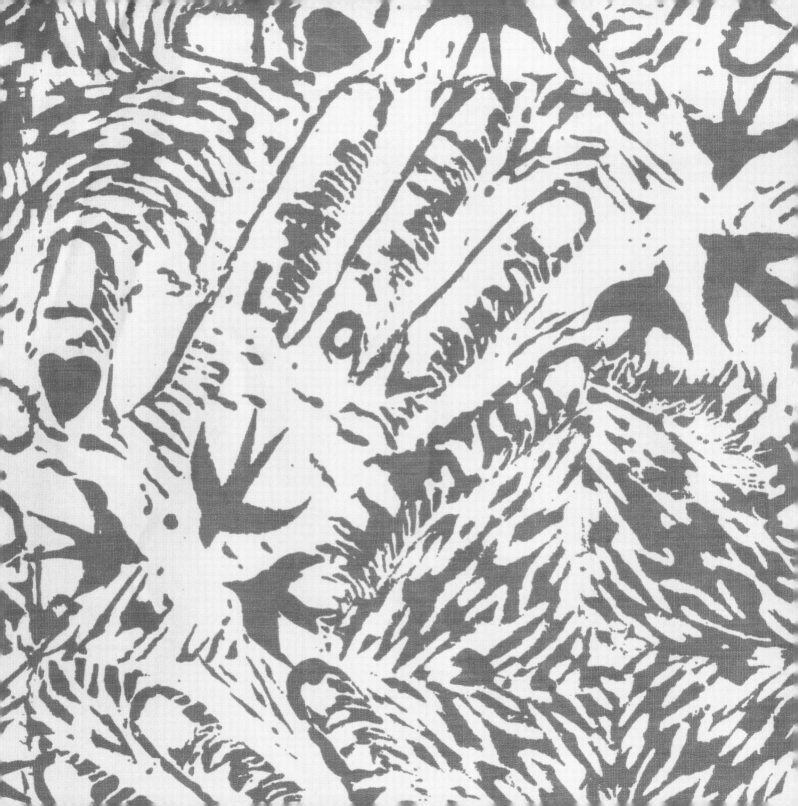

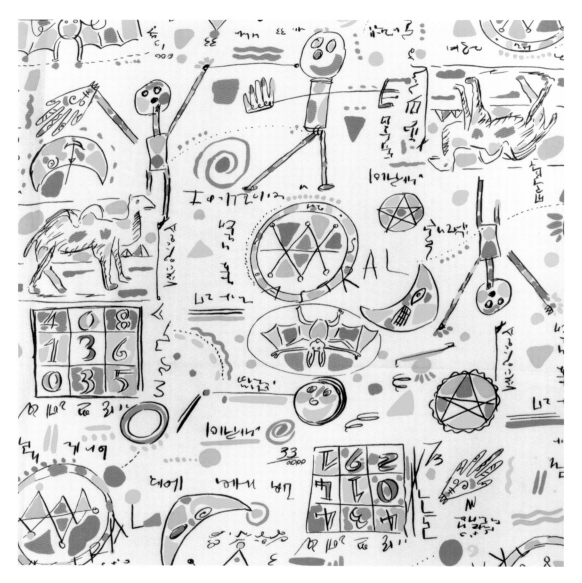

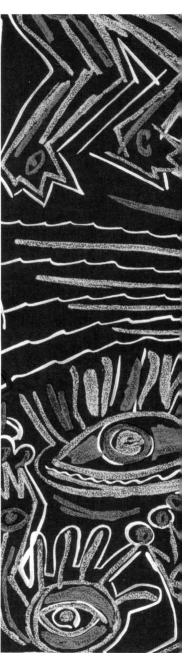

Above: A whimsical design of childlike stick figures and toys by Furphy Simpson, bought by the Austrian company Rhomberg.

Right: A design by Furphy Simpson used by both British designer and retailer Paul Smith and British retailer Next Menswear, though in different colourways. The design utilizes the wax-resist technique.

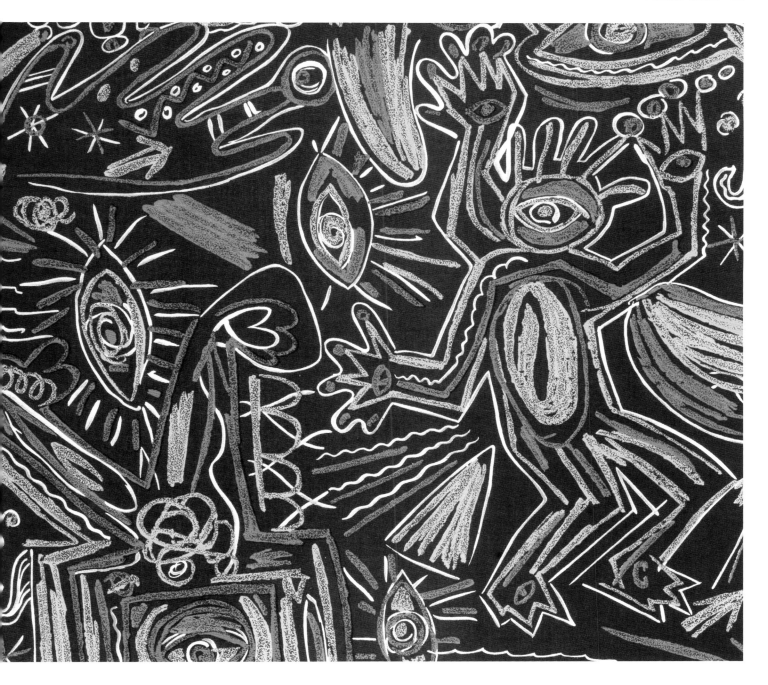

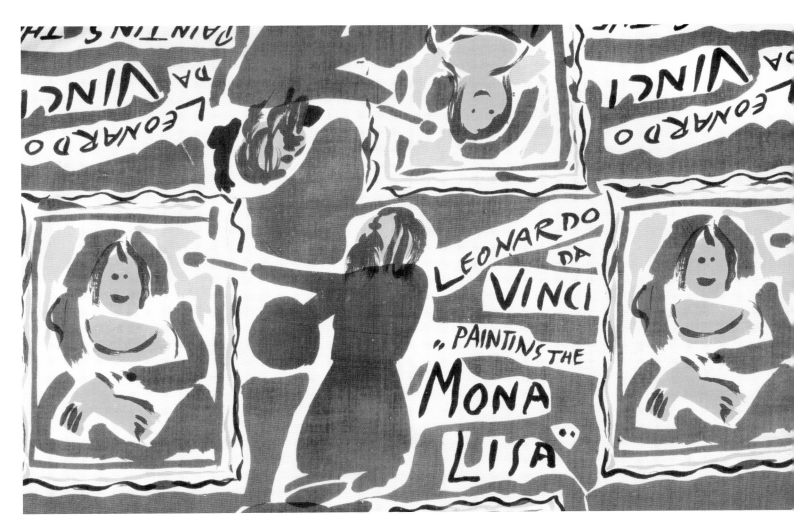

Left: A mixed-media design referencing the pop-art artist Roy Lichtenstein in imagery reminiscent of a comic book and its use of printing dots. From the sketchbook of the English Eccentrics designer Helen David.

Above: From a series called 'Great Moments in History', this witty design by Furphy Simpson features Leonardo da Vinci painting the iconic *Mona Lisa*. The print was used for men's shirting.

Far left: The controlled use of colour in *Zoom*, from the 'Megaphone' collection, designed by Britt-Marie Christofferson of the Swedish group Tio-Gruppen in 1983, is executed with mathematical precision.

Left: *Meteor*, from the 'Megaphone' collection, features attention-grabbing motifs and hectic patterning. By Birgitta Hahn of Tio-Gruppen in 1983.

Right: Predating the Memphis group by a decade, the Swedish design group Tio-Gruppen displayed a post-modern attitude to pattern. This design references the Art Deco fan/sunrise motif. *Helios* (named after the Greek personification of the sun) is from the 'Megaphone' collection and was designed in 1983 by Ingela Håkansson.

Above: *Bongo*, from the 'Signal' collection designed by Tom Hedqvist for Tio-Gruppen in 1985, is a pastiche of 1950s style.

Right: Two designs from the 1985 'Signal' collection by Tio-Gruppen: *Radio X* by Tom Hedqvist, and *TamTam* by Inez Svensson.

Far left: An all-over spot repeat, *Chio*, designed by Ingela Håkansson of Tio-Gruppen, from the 'Signal' collection in 1985.

Left: *Harlekin*, from Tio-Gruppen's 1980 'Play' collection, designed by Tom Hedqvist, references the costume of the character Harlequin, from the *commedia dell'arte*, a form of improvisational theatre that began in Italy in the sixteenth century.

Right: This design of lively motifs and an intentional, slightly misplaced registration of colour, exudes energy. *Buzz* – from Tio-Gruppen's 1985 'Signal' collection – was designed by Birgitta Hahn.

Far left: *Intervall*, a screen-printed cotton furnishing fabric from the 'Play' collection, inspired by the performances given by the Swedish ballet in Paris in the 1920s. Designed by Susanne Grundell and printed by Borås Wäfveri for Tio-Gruppen, 1980.

Left: *Jazz* from the 'Play' collection: screen-printed cotton furnishing fabric designed by Britt-Marie Christoffersson, and printed by Borås Wäfveri for Tio-Gruppen in 1980.

Left: This design, *Lek*, from the 'Play' collection by Tio-Gruppen in 1980, was designed by Birgitta Hahn and displays 1950s levity.

Left: *Buenos Aires*, from the 1986 'Metropolis' collection: a screen-printed cotton furnishing fabric designed by Birgitta Hahn, printed by Borås Wäfveri for Tio-Gruppen.

Left: A poster showing elements of the print designs by Tio-Gruppen that made up the 'Metropolis' collection, which was shown at the Lammhult Exhibition at Nybro Pavilion in Stockholm in 1986.

Above left: A deceptively simple print design utilizing positive and negative space in two colours. *Monte Carlo*, from the 'Metropolis' collection, designed by Tom Hedqvist in 1986 for Tio-Gruppen.

Above: *Casablanca*, from the 'Metropolis' collection, a one-colour print designed by Gunilla Axén in 1986 for Tio-Gruppen.

Left: African masks provide an intriguing and witty composition in this design, *Luanda*, from the 'Metropolis' collection. Designed by Ingela Håkansson for Tio-Gruppen in 1986.

Above: Two designs by Furphy
Simpson bought by the French
printing company Jenast,
suppliers of printed fabrics to
Parisian couturiers. These were
printed on white crepe de Chine.

Above: Original artwork by Furphy Simpson of a print design utilizing brushstrokes and a *tjanting* (batik tool) with runny dye to obtain the organic, dribbling effect.

Right: A Furphy Simpson print design deploying a double discharge technique; brushstrokes and wax drawings were enlarged on a small screen.

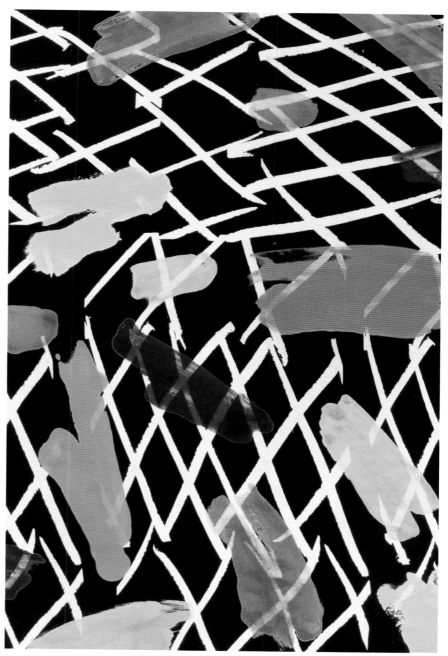

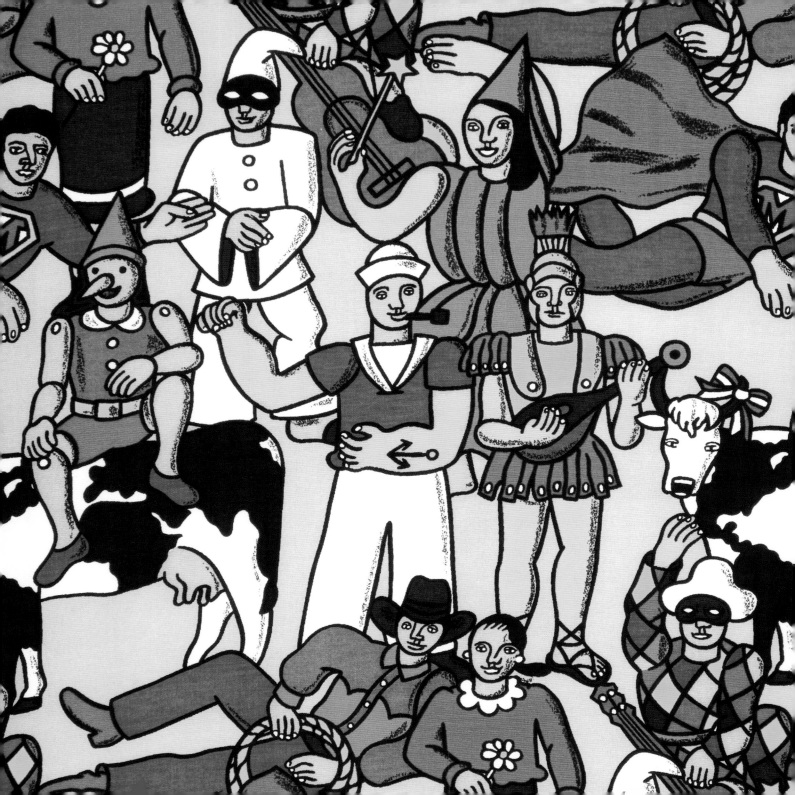

Left: A half-drop repeat print by Moschino, featuring the male form in various guises – from super heroes, cowboys and Roman centurions to characters such as Harlequin, from the *commedia dell'arte*.

Right: Franco Moschino showed his first fashion collection for women in Milan in 1984. Always the *agent provocateur*, his use of print was irreverent and witty, as in these images of comical, multi-patterned cows. Following the success of his 'Cheap and Chic' collection in 1988–9, he decided, in 1991, no longer to show on the catwalk, producing statements such as 'Stop the fashion system' and 'Warning: advertising can cause serious damage to your brain and your wallet'.

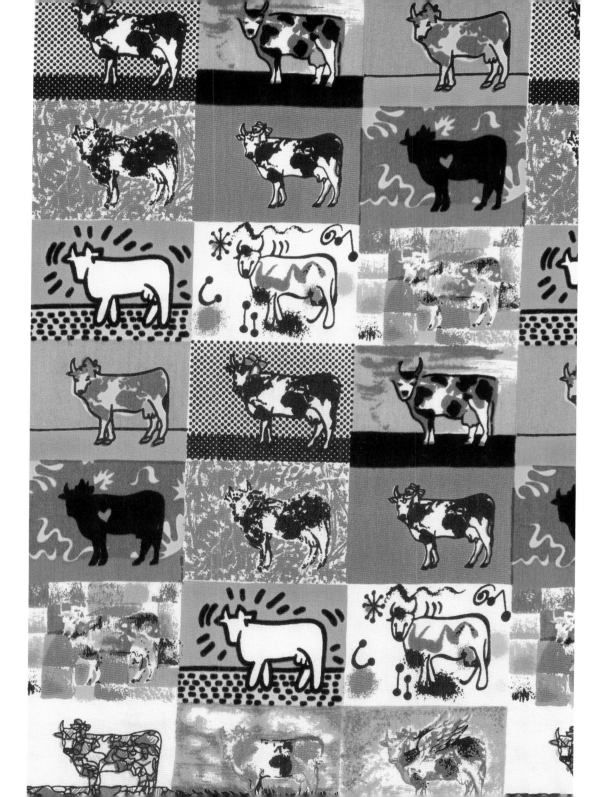

2 GLAMAZON

The 1980s heralded a new feminine ideal. Eileen Ford, of the eponymous New York model agency, described her as having 'a firm body, healthy hair and skin, and a look of serene determination. Today, health is beauty'. The perfectly honed and groomed 'glamazon', striding along the catwalk in her stiletto heels, represented the new feminism. The spike heel came to symbolize the power and sexuality of the 1980s woman, as Caroline Cox remarks in her book *Stiletto*: 'The high heel was a mark of conspicuous consumption worn by women who showed their considerable wealth and social status through their feet.' British designer Bruce Oldfield concurred. 'Less is no longer enough; now it's glamour, glamour, glamour, glamour,' [1] he told *Vogue* at the beginning of the decade.

The miniskirt of the 1960s dolly bird became the micro-skirt of the 1980s glamazon when worn as part of the newly assertive tailored silhouette. The shoulder pad, emblem of the era, became ever bigger as the decade progressed, reaching extreme proportions in American TV shows such as *Dynasty*, where leading protagonists Joan Collins and Linda Evans shouldered

1. Bruce Oldfield, *Vogue*, August 1981, p. 55.

Right: Heraldic pennants, chains and flowers are given extra interest by the textured brocade background.

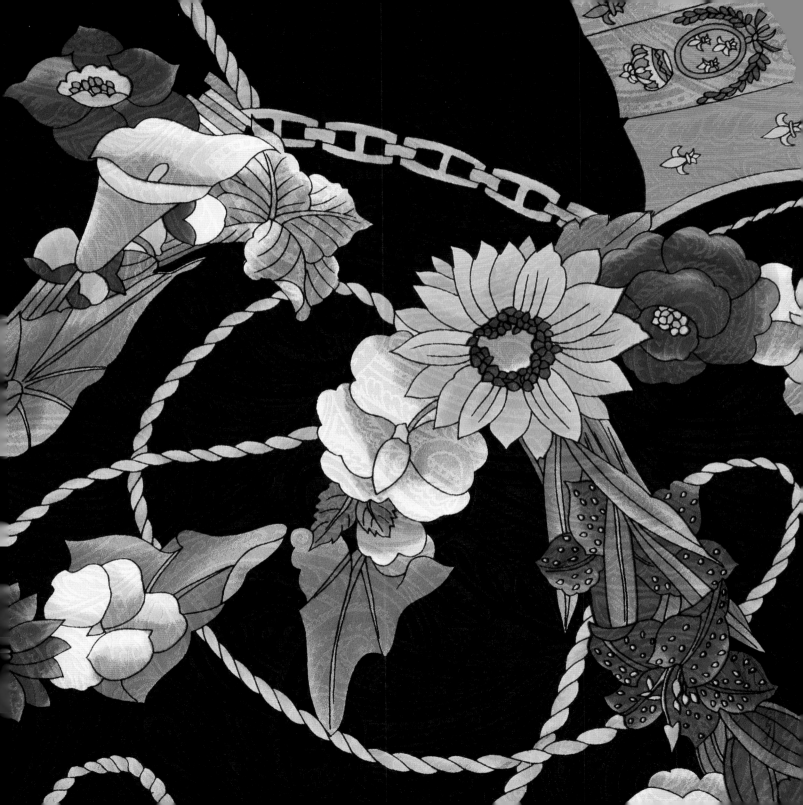

each other out of the way as they fought for screen space in their roles as Alexis and Krystle Carrington. The shoulder pad was so ubiquitous that it became a detachable accessory, worn even under knitwear.

This Amazonian silhouette accommodated dramatic statements in print design that utilized bold, look-at-me colour in striking combinations: turquoise and fuchsia, canary yellow and bottle green, scarlet and purple, lilac and ochre. Ostentatious patterning encompassed *trompe l'oeil* effects of chains, swags, knots, bows and ribbons, as well as animal prints. The blouse was the garment that feminized the female executive's power suit and offered the opportunity for print. Patterned collars and cuffs, pulled out from beneath a jacket's sleeves, softened the solid blocks of tailoring and the formality of the gilt buttons and sharp reveres of the jacket.

Right: A classic rich paisley print on this dress by the American couturier Bill Blass, a favourite designer of the US president's wife, Nancy Reagan.

Left: *Trompe l'oeil* – a visual illusion that tricks the eye into perceiving a flat object as three-dimensional – was a popular feature of 1980s print design. This silk is printed with cords and tassels, luxurious decorative textile trimmings more commonly known as *passementerie*.

The 1980s obsession with display and the perfectly honed body, athletic yet sexy, met in the aesthetic of the Italian designer Gianni Versace. The designer of choice for the super-rich, he represented the moneyed excess of the era and became a symbol of Italian luxury. Versace founded his company in 1978 and showed his first collection for women the same year. With an aesthetic that combined high art and contemporary culture, his adopted crest was the head of the Medusa, the mythical female character whose gaze turned onlookers to stone. The motif symbolized the decadent glamour and dangerous allure of the label and was featured in many of his print designs. Sex was the key to Versace's work: using clinging, metallic fabrics and opulent decoration on garments slashed to the waist or cut down to the buttock, his signature style pushed the look to the edge of vulgarity while still retaining a fashion sensibility.

More formal splendour was the remit of the 'occasion dress' exemplified by designers such as Oscar de la Renta, who remarked, when Ronald Reagan was elected to the presidency, that after the cosy informality of the Carter years, 'the Reagans are going to bring back the kind of style the White House should have.' The party culture instigated by the Reagans' eagerness to assure their social standing with the cream of New York society provided plenty of opportunities for competitive dressing up and subsequently regenerated the businesses of designers such as Bill Blass, Oscar de la Renta, Adolfo and James Galanos. Lustrous textures, layered embellishment of print and embroidery, big shapes – fashion meant lavish consumption. Kitty Kelley wrote in her biography of Nancy Reagan: 'They displayed what was to become the hallmark of the Reagan era: bright, shiny, new noisy wealth that is most often seen in long limousines, rustling furs, ornate gowns and jewels the size of cowpats.' [2]

2. Kelley, Kitty (1991). *Nancy Reagan: The Unauthorized Biography*. New York: Simon & Schuster, p. 267.

Left: *Trompe l'oeil* braid and tassels given a nautical overtone with the inclusion of medals, lanyards and flags.

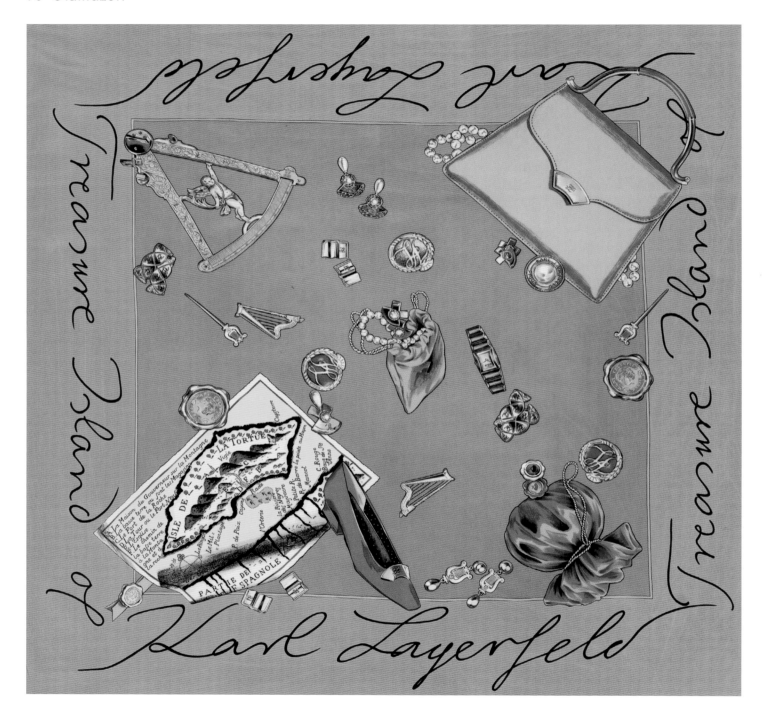

Left: Decorative head-squares became popular during the 1940 and 1950s; by the 1980s, couture houses were including them in their accessory ranges as an accessible way for customers to buy into the label. The treasures referred to in the words 'Treasure Island', inscribed on this scarf by the Parisian couturier Karl Lagerfeld, refer to bags of golden jewels, pearls, a watch, handbag and shoes.

Right: Emblazoned with the motifs of conspicuous consumption – credit cards, shopping malls and fashion labels – this silk dressing gown by the American designer Nicole Miller illustrates all the cultural ephemera of the 1980s.

Left: An understated printed silk design by the Italian label Gucci, the faux-tweed effect created by varying scales in rows of tiny flowerheads.

Below left: Print for a tailored jacket in wool crepe by the British designer Jean Muir. Renowned for the understated simplicity and sophisticated technique of her cutting, and use of navy and black, even this most uncompromising of designers produced the essential element of every businesswoman's wardrobe, a power-shouldered jacket, here in bright red with a subtle, Japanese-inspired print.

Right: The most recognizable logo in fashion – the overlapping double Cs of the Parisian couturière Coco Chanel – was designed by her in 1925 and remains unchanged today. The scarf is illustrated with *trompe l'oeil* images of jewellery. The designer set the trend for costume jewellery and precious stones in informal settings in the 1920s, an irreverent and democratic approach to displaying wealth entirely in keeping with the excesses of the 1980s.

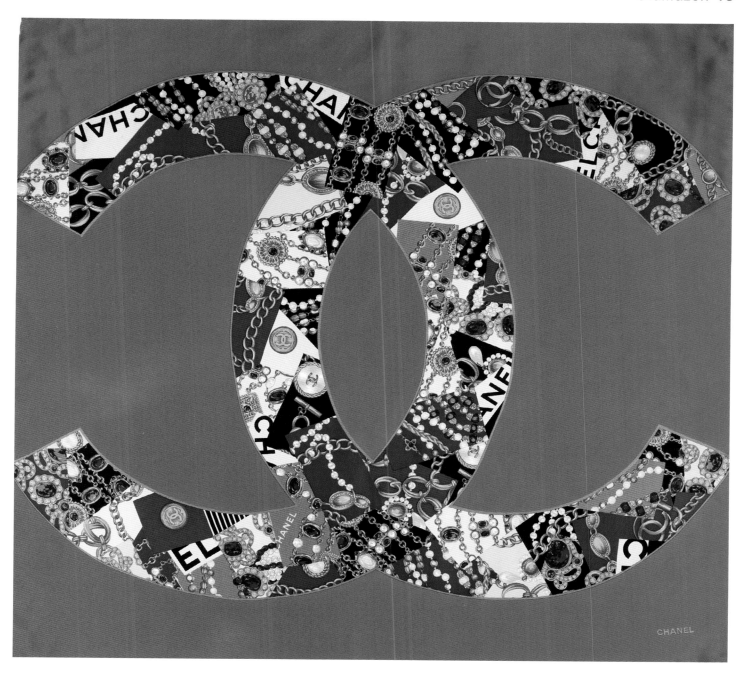

Left: The white camellia is the iconic symbol of the French couture house Chanel. Here the motif is combined with *trompe l'oeil* ribbon in a shift dress for the Chanel Boutique.

Left: *Trompe l'oeil* braids and rosettes feature in this design by Helen David of English Eccentrics.

Right: Hyper-real, large-scale blooms distinguish this design by Furphy Simpson.

3 CATCH THE WAVE

During the unprecedented financial prosperity of the 1980s, sport became commercialized. Global labels and big brands such as Adidas and Nike exploited a burgeoning preoccupation with health and fitness by marketing sportswear in the same way as a fashion label. Sophisticated marketing strategies and a global media industry resulted in a massive increase in turnover. The emergence of modern sportswear acknowledged the provenance of the design, performance and practicality, but also took into account the desirability of exclusivity in the label on the street.

Surfing, skateboarding, skiing and 'feeling the burn' were all activities that demanded specialist clothing in fabrics that featured high-voltage imagery. The gym culture popularized by the film actress Jane Fonda in her workout videos, and films such as *Fame* (1980) and *Flashdance* (1983), fuelled the impetus for men and women to show off a body honed and toned to perfection by intensive exercise. This new, muscular physique was enhanced by the inclusion of the synthetic fibre Spandex or

Right: The glamazon heads to the islands in this design, *Bliss*, from the 'Maui Scenics' collection by Alexander Henry Fabrics.

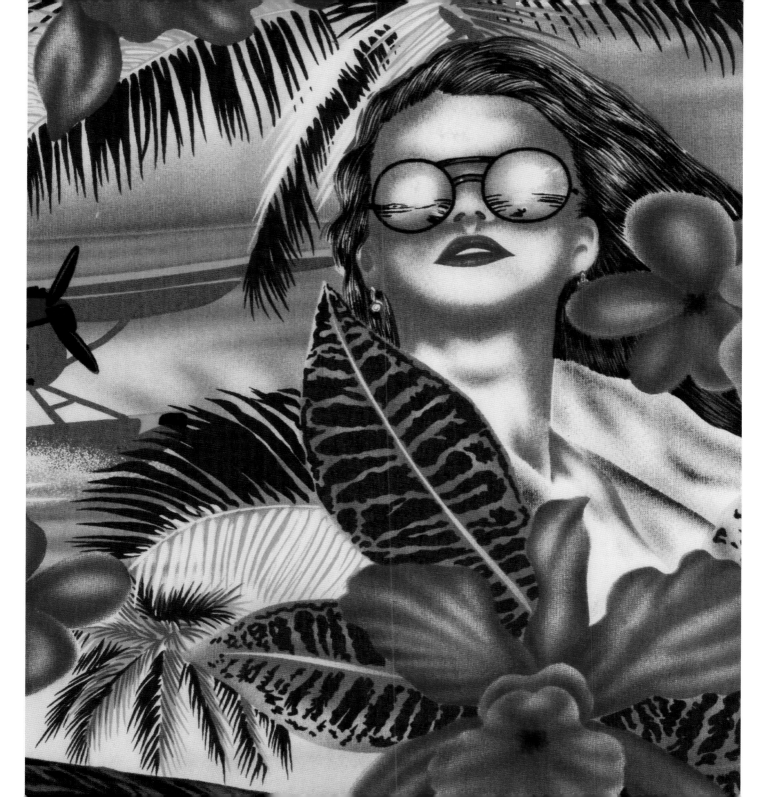

Above: Torn, collaged paper provides a background suggestive of the seaside, whilst superimposed heavy line drawings of black emulsion paint suggest a shoreline of holiday hotels. T-shirt design by Furphy Simpson.

Elastane (a generic term: the most famous brand name is Lycra, a trademark of the Invista company), into garment production. This magical stretch yarn was first invented by DuPont in 1959; its unique property was an ability to stretch over 500 per cent without breaking, allowing the garment to remain skintight even after extended wear. According to author Bradley Quinn, the use of Lycra will be forever associated with the 'body-conscious culture of self-improvement, body sculpting and healthy living linked to the narcissistic culture of the 1980s and 1990s.'[1] In high fashion it allowed Azzedine Alaïa and Hervé Léger, who competed for the title 'King of Cling', to design figure-hugging dresses that delineated every curve.

In sportswear, Spandex provided comfortable and contour-enhancing garments that allowed full movement while still retaining their shape. This new ease of fit extended from sportswear to leisurewear, providing a marked contrast to the strict tailoring of the on-duty business suit. The foremost exponent of this aesthetic was the American designer Norma Kamali, who produced cotton fleece sweats inspired by exercise and dance garments, including the oversized sweatshirt worn as a dress over a leotard and legwarmers. Lycra was also an important element of the 'body', the American designer Donna Karan's answer to a smoother silhouette. This was a combination of the 1970s bodystocking and the dance leotard, worn as an alternative to the blouse under a power suit.

In America, the cult of the body and the emergence of sporting subcultures such as surfing and skateboarding opened up new avenues for the print designer. In 1980, the cult Californian surfboard-shaper, Shawn Stussy, applied his graffiti-tag logo to T-shirts that he sold alongside the boards. The T-shirt is the most democratic of garments. Literally a blank canvas, the

1. Quinn, Bradley (2002). *Techno Fashion*. Oxford: Berg Publishers, pp. 185–200.

accessibility of the screen-printing process renders it one of the simplest ways to kick-start a label. Embellished with images or text, it is used for promulgating ideas, promoting brands or music tours, or as a message board for subversion. Stussy made the crossover from sportswear into an international urban streetwear label with the assistance of the New York fashion stylist Patricia Field. The emergence of the brand converged with the growing popularity of hip-hop culture, then entering the American music mainstream.

Towards the end of the decade, rave culture, an explosive collision between the acid house music coming out of Chicago and the introduction of new drugs such as MDMA, the 'designer drug' commonly known as Ecstasy, crossed class and social divides. Free and illegal gatherings of thousands of people in warehouses, aircraft hangers and industrial sites, initially a British phenomenon, soon caught on in major urban centres across America. Unlike the drug of choice of the previous summer of love in 1968, when psychedelic patterning was fuelled by LSD, the 'smiley' culture, fuelled by Ecstasy, was represented by customized trainers, tie-dyed T-shirts, Day-Glo colours and neoprene.

Below: A Furphy Simpson design for the sportswear company Adidas in 1989. The motifs were printed on items worn by the Wimbledon tennis champion Stefan Edberg, and also appeared on labels, shorts and socks.

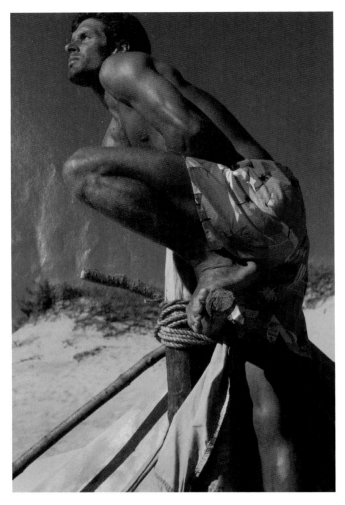

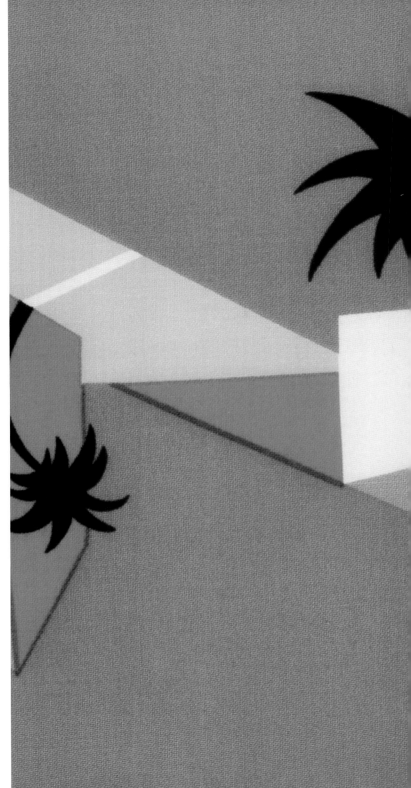

Above and right: This design, *6.10.80*, from the 'Wave' collection, was the first textile design by Phillip de Leon for the design company Alexander Henry Fabrics. Nicole de Leon and her brother Phillip produce two new collections annually with their father Marc de Leon, and also market fabrics worldwide. The company sells prints to a diverse range of clients, from cutting-edge designers to large corporate manufacturers.

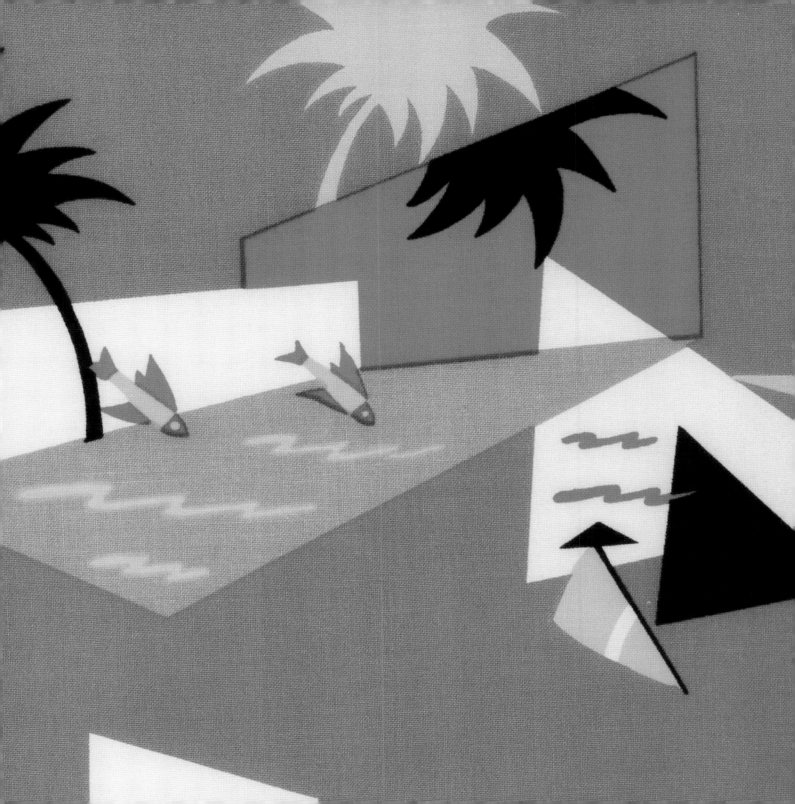

Left: A performance-packed print design, *Pow*, from the 'Wave' collection by Alexander Henry Fabrics.

Right: *It's a Blast* from the 'Metro' collection by Alexander Henry Fabrics. California-based print design company Alexander Henry Fabrics was uniquely placed to catch the wave of a new generation of surfers with their textile designs.

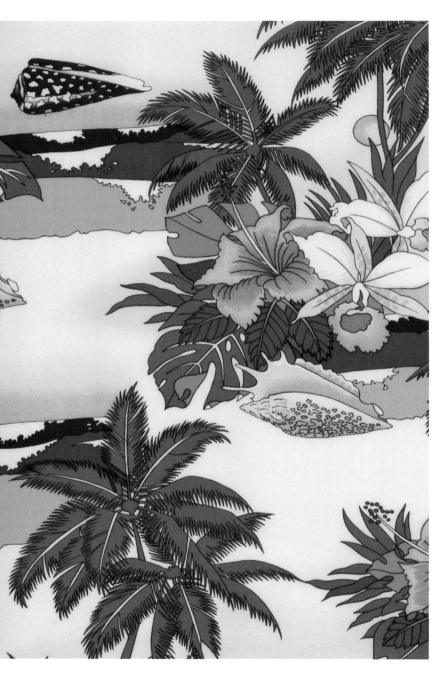

Left: Surfing produced its own genre of imagery. Originating in Hawaii and Polynesia before spreading to California and Australia, modern graphic renditions of traditional Hawaiian motifs and tropical plants in vibrant colour combinations appeared on 'jams' or cotton board shorts popularized by surfers, as in this design, *Oahu*, from the 'Maui Scenics' collection by Alexander Henry Fabrics.

Right: *Paradise,* from the 'Maui Scenics' collection by Alexander Henry Fabrics.

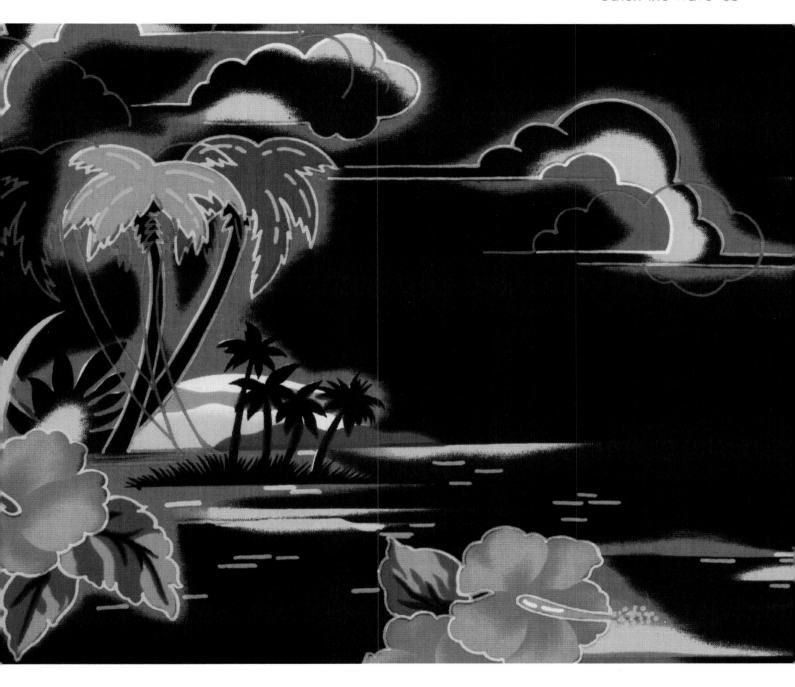

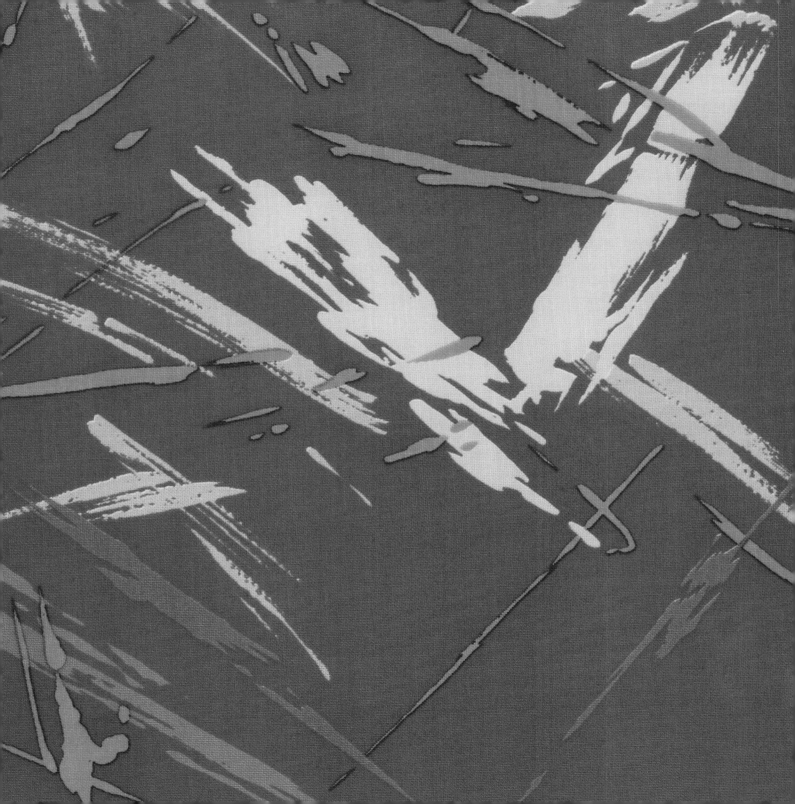

Left: This design for cotton board shorts, *Strokes*, by Alexander Henry Fabrics, provides high visibility for the surfer with expressive slashes of bright colour.

Right: The sketchily drawn lines interrupting the broader sweeps of deckchair-coloured stripes are suggestive of the refraction of light on sea, sand and the horizon in this eight-colour print by Liberty.

French Connection '89.

Above and right: Monoprint and torn paper overlaid with black emulsion paint describes figures at the beach in this T-shirt design by Furphy Simpson for the British design company French Connection, together with a playful all-over print design of a beach scene in a half-drop repeat.

Above: When the reggae artist Bob Marley appeared on stage wearing football gear and tracksuits, it kick-started a trend amongst urban black youth and was subsequently adopted into mainstream fashion. Tracksuit print design for the sportswear label Adidas, by Furphy Simpson. This design uses a variety of media: coloured paper spots, brushstrokes, pen and ink, and photographic imagery.

Left: Tracksuits and shell suits were initially a quick and convenient way to cover exercise clothes on the way home from the gym, but then became a staple of general leisurewear. Made up of a lightweight, front-zippered nylon top and matching loose trousers with cuffed ankles and an elasticated waist, their easy-care comfort was eventually designated the major style crime of the decade. Striking patchwork combinations of colours – purple with green, royal blue and red – were combined with inserts of computer-generated prints.

Left: Print design by Furphy Simpson for the British label Next, utilizing spray paint over torn paper and printed on polyester chiffon.

Right: Polychromatic zigzag stripes in this print design by Furphy Simpson, sold to the Australian label John Kaldor.

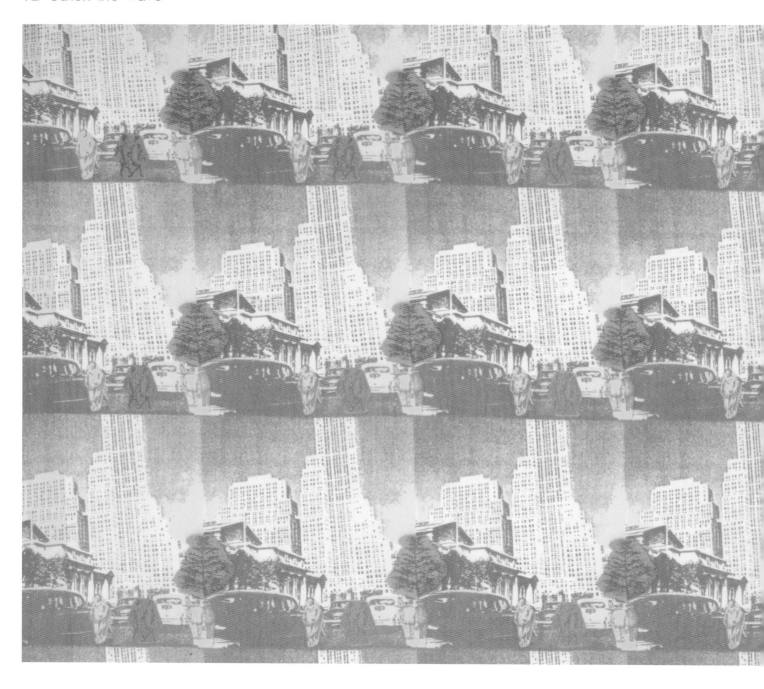

New York (left) and *Moonlanding* (right) are two designs from the same series by Furphy Simpson. Both were executed on paper using an Omnicrom machine and printed on nylons and cotton.

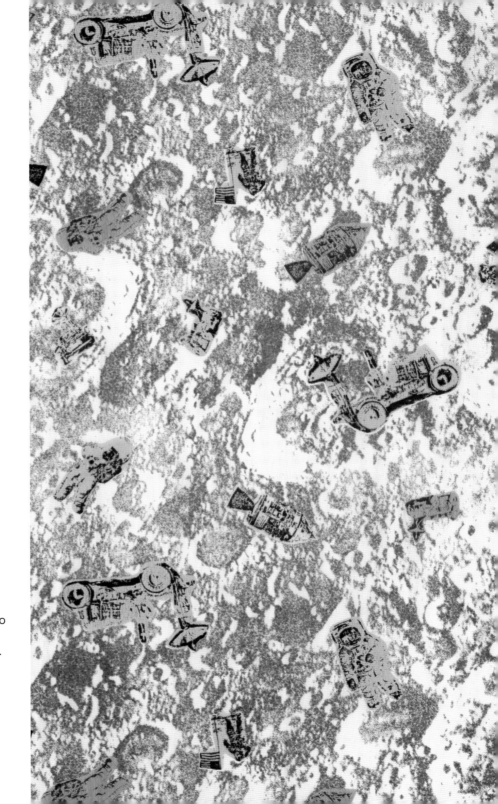

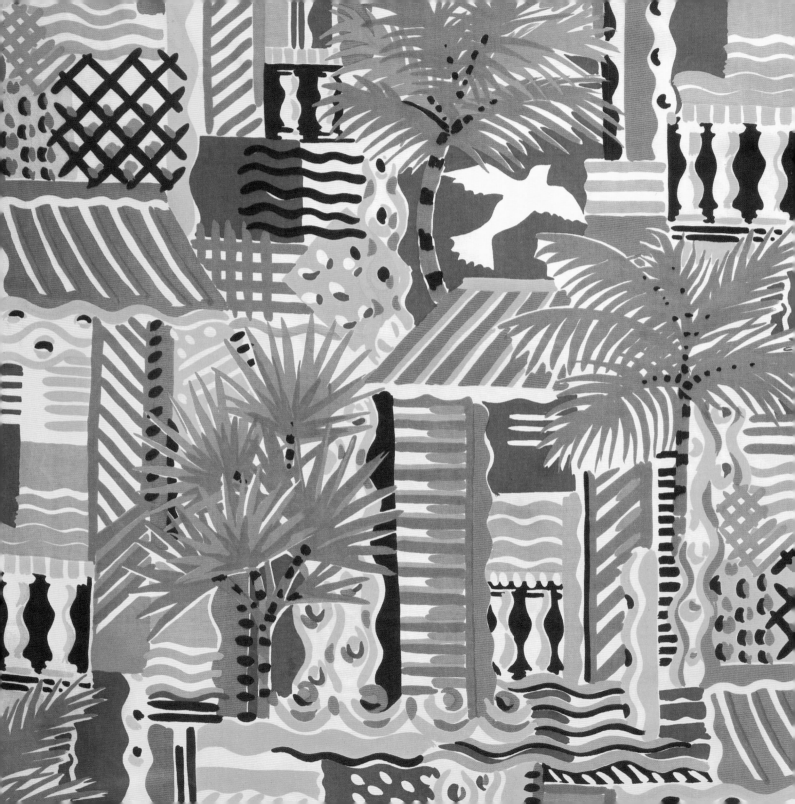

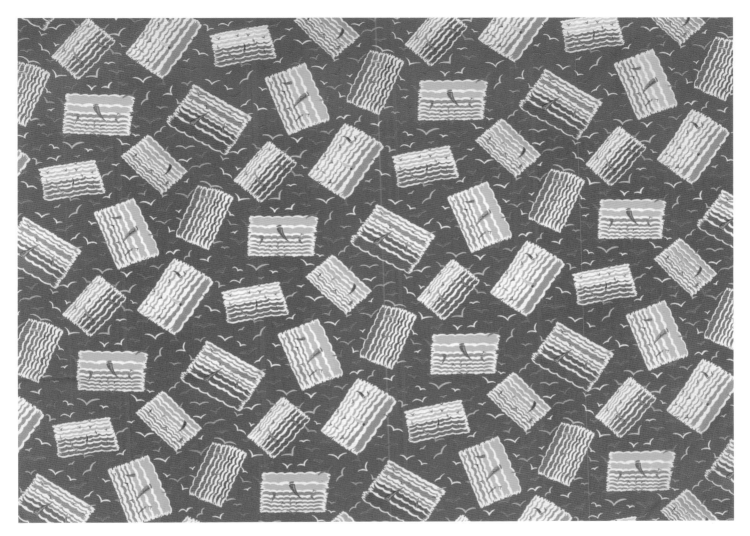

Left: The partnership of Susan Collier and Sarah Campbell was renowned for producing a distinctive range of designs with a rich colour palette and intense patterning. *Côte d'Azure* is a screen-printed cotton furnishing fabric designed by Collier Campbell and produced by the Swiss company Christian Fischbacher in 1983. The fluid, painterly marks and simple cut-outs are suggestive of the work of Matisse. This design was one of the 'Six Views' collection, which won a design award in 1984.

Above: A cheerful, all-over seasonal design by Liberty: seaside postcards floating on a background of waves and seagulls.

4 URBAN JUNGLE

In fashion there is a persistent desire for narrative – clothes that are not concept-led or concerned with a particular aesthetic, but which tell a story about the world and other cultures. Mainstream fashion perennially offers some version of the 'boho' look, in which pattern and print plays an integral part, even though the major trend might be one of strict tailoring or architectonic design. In the 1980s, although power dressing occupied centre stage, this desire for the alternative was supplied by the Italian label Etro and their elegant and luxurious version of the avant-garde. In 1981 the company appropriated the paisley motif – that potent symbol of laid-back decadence – to mark the creation of their womenswear brand. Turkish-born Rifat Ozbek, a graduate of Central Saint Martins in London, also looked to folklore and other cultures for inspiration. In 1984 he established his own company and reputation with a collection that he called 'Africa'. This juxtaposition of prints and surface embellishment in patterns of varying scales and colourways offered a more eclectic and idiosyncratic way of dressing.

Right: *Tiger, Tiger* is a discharge print design on black velvet, by freelance textile designer Natalie Gibson, who also lectures on printed textiles for fashion at London's Central Saint Martins College of Art and Design.

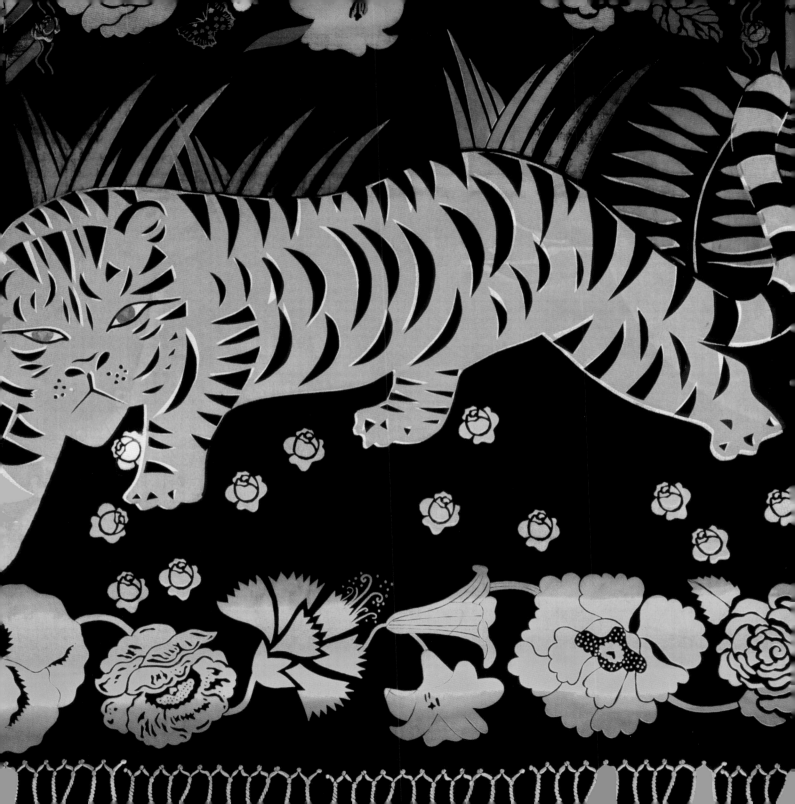

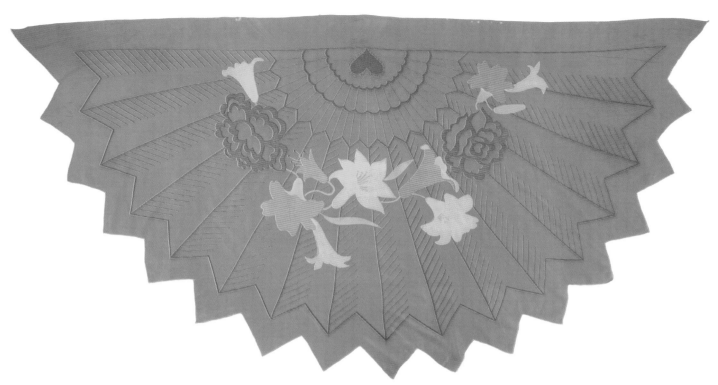
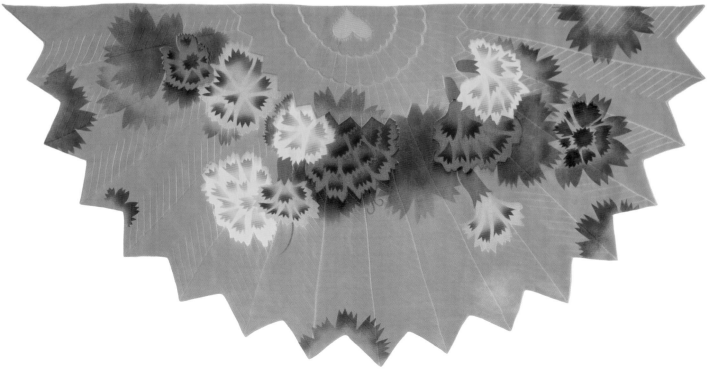

A defiantly urban era, there was still a place in the 1980s for floral print design, though in keeping with the age, these were not timid pastels but exotic, multicoloured, all-over images that contained more figure than background. Large-scale flower prints exploded with exotic blooms in huge pattern repeats, and hothouse specimens shimmered with vibrant colour. There was no element of the botanical or analytical about the depiction of flowers in 1980s print: their portrayal was either semi-abstract or impressionistic, in fantasy colour combinations. The floral print was generally non-directional, allowing the pattern-cutter greater freedom to produce layers of diverse designs of differing scales and bold colour. These were intended to be worn together in one dazzling outfit, in a mix-and-match approach to pattern exemplified by the Japanese-born designer Kenzo Takada. His boutique, Jungle Jap, was located in the Galerie Vivienne and was inspired by the painter Rousseau, with the ambience of a tropical rainforest.

The fashion silhouette for these dramatic floral prints was generous. Daywear included the wide-shouldered, mid-calf dress, usually belted, and for more formal events, the 'occasion dress' – which flaunted a multiplicity of crinoline-like folds, providing a perfect canvas for extravagantly exaggerated blooms. The new urban leisurewear, consisting of loosely cut T-shirt shapes knotted over the hips, with deep armholes and wide, slashed necklines, also provided the print designer with the opportunity for surface decoration.

Left: A pair of printed shawl designs by Natalie Gibson, designed for the exhibition 'Gaudy Ladies' at London's Royal College of Art in 1982. Other exhibitors included Barbara Brown, Mary Restiaux and Marta Rogoyska.

High-octane bohemian glamour was supplied by the French designer Christian Lacroix, who opened his couture house in 1987. As the decade progressed, Lacroix replaced the upturned triangle of the wide-shouldered silhouette and focused emphasis on the width of the hem. His complex garments, incorporating a plethora of cultural references in dazzling combinations of colours, used print, pattern and embellishment.

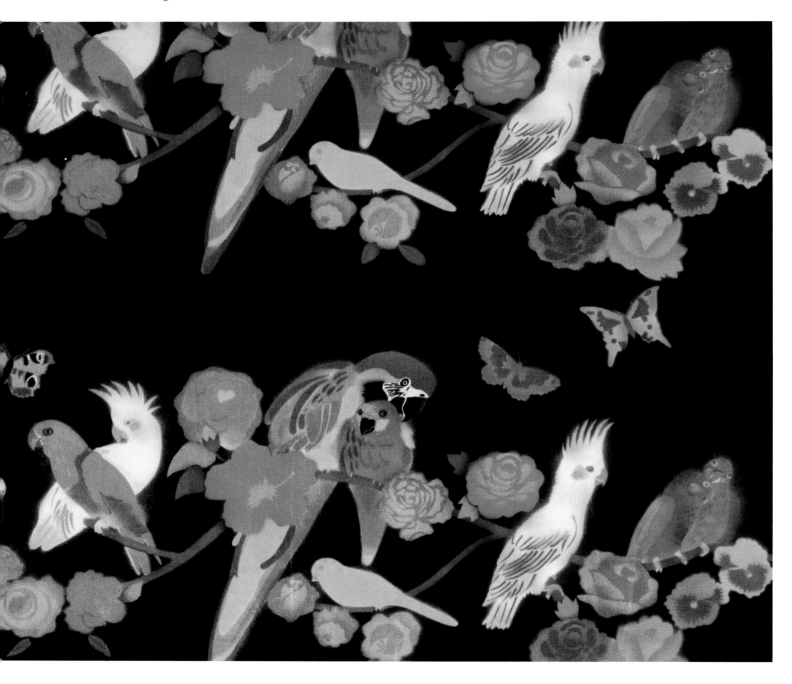

Left: Birds are a recurring theme in Natalie Gibson's work. This discharge print on black velvet incorporates airbrushed stencils of parrots and cockatoos with butterflies and flowers.

Above: Wild and domestic cats float on a turquoise velvet background in this all-over print design by Natalie Gibson.

A series of images, from stalking cats to Art Deco vases, from a screen-print designed and printed by the discharge method and hand-painted on black silk by Natalie Gibson for the exhibition 'Gaudy Ladies'.

This page: Chinoiserie-inspired wall hangings by Natalie Gibson, utilizing the discharge method on a silk ground combined with airbrushed floral motifs.

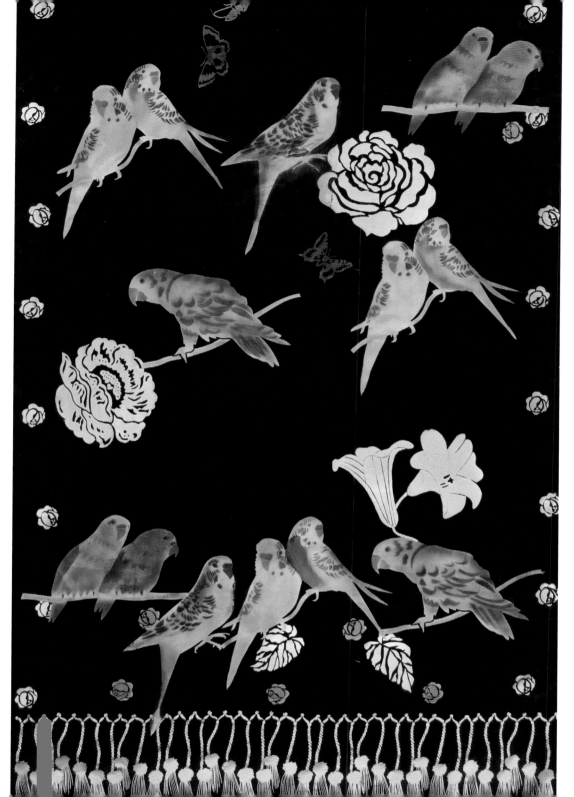

Left: Parrots and
budgerigars perch over
trompe l'oeil tassels
stencilled on black
velvet in this design
by Natalie Gibson.

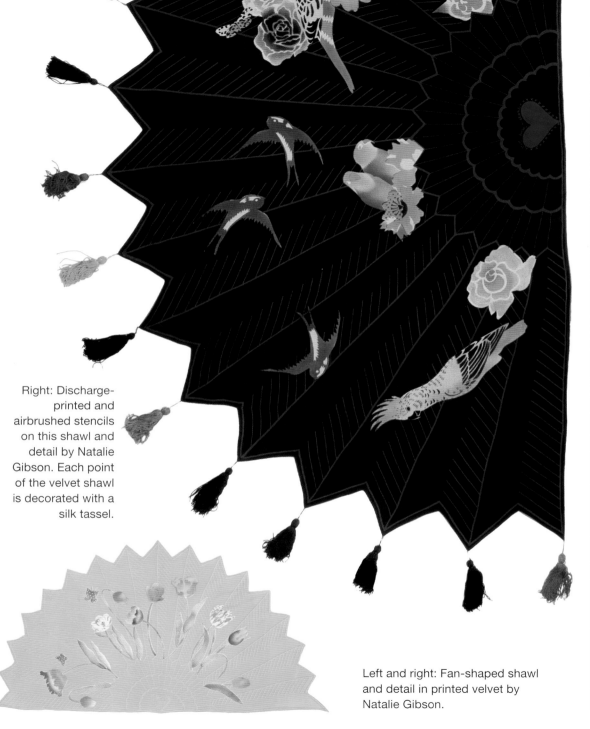

Right: Discharge-printed and airbrushed stencils on this shawl and detail by Natalie Gibson. Each point of the velvet shawl is decorated with a silk tassel.

Left and right: Fan-shaped shawl and detail in printed velvet by Natalie Gibson.

Above: A mixed-media print design by Furphy Simpson, which demonstrates their facility with the technique of discharge printing. Furphy Simpson continues to include all genres of print design in their practice, but their collections always incorporate a range of floral designs. The company has always considered that the printing process is a creative act, and the partners are very 'hands on' in terms of developing ideas through the medium of various techniques. These include monoprints, cut-paper stencils, hand-painted brushmarks, pen and ink, and linocuts, which are all used in the pursuit of the final realization of the idea. Towards the end of the 1980s, processes became more sophisticated, and the design duo incorporated photographic techniques and half-tones.

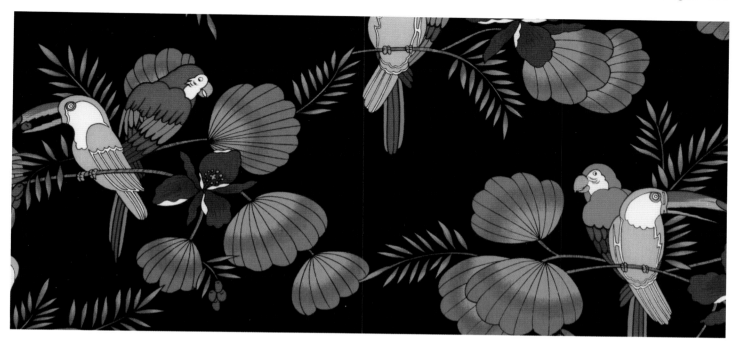

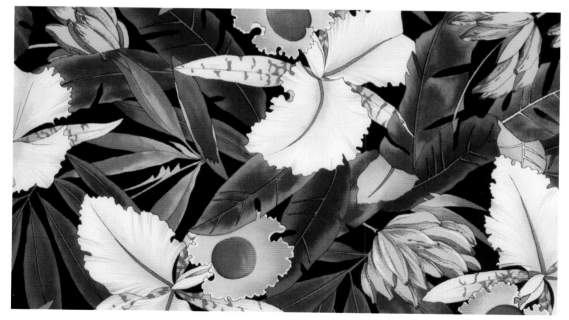

Above: *Toucan Dance* from the 'Torrid Zone' collection by Alexander Henry Fabrics.

Left: *Banana Leaf Orchid* from the 'Torrid Zone' collection by Alexander Henry Fabrics.

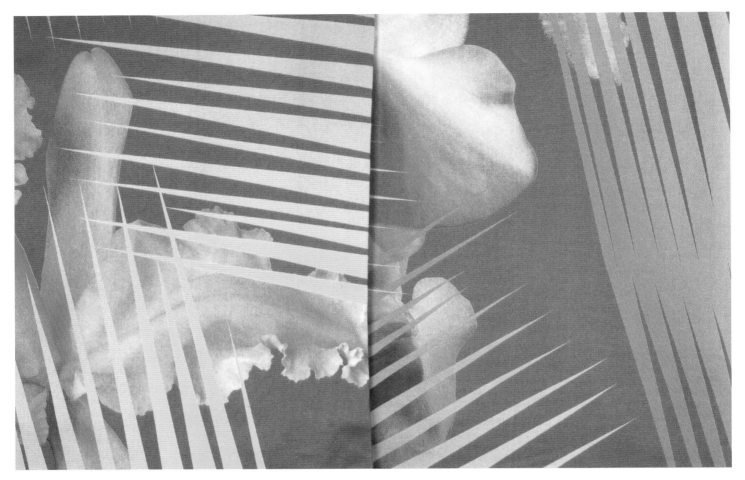

Above: Large-scale exotic flowers are dissected with the stripes of palm fronds in this early photographic print from the Versace diffusion line, Versus.

Right: *Mango Republic* from the 'Africa' collection by Alexander Henry Fabrics.

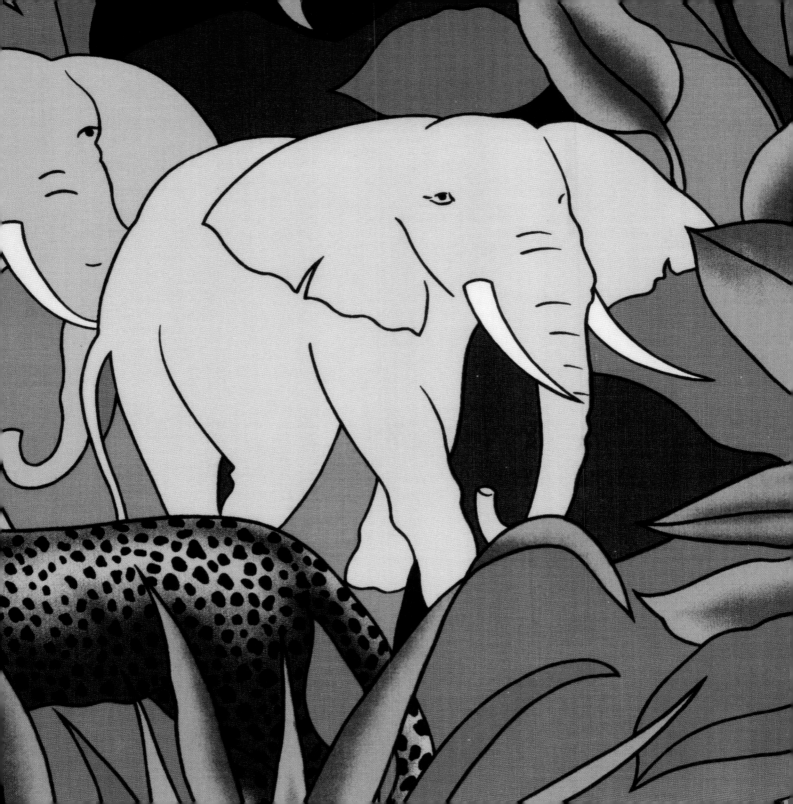

Above: Liberty, the London store, was founded in 1875 by Arthur Lasenby Liberty. The store initially imported textiles and *objets d'art* from Asia, and was linked to the aesthetic movement of the 1890s and Art Nouveau. These influences can be seen in the deep, rich colours and graphic lines of this design for a scarf.

Right: *Palm Leaf,* from the 'Sunsplash' collection by Alexander Henry Fabrics.

Above: A subdued but intense print on a wool crepe dress by the Italian-born couturier Emanuel Ungaro, a favourite designer with the cast members of the American television soap *Dynasty*.

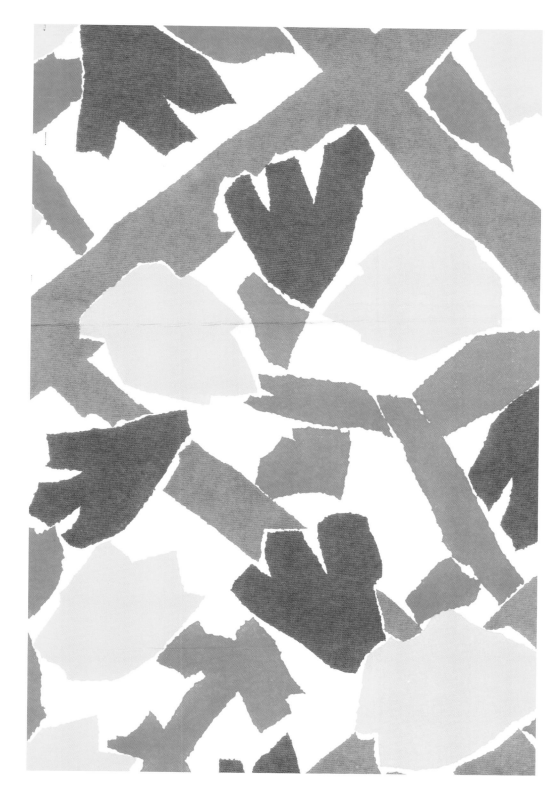

Right: A direct interpretation of collaged artwork with colours from opposite ends of the spectrum. The torn edges of the paper add necessary texture to the simplicity of this design by Liberty.

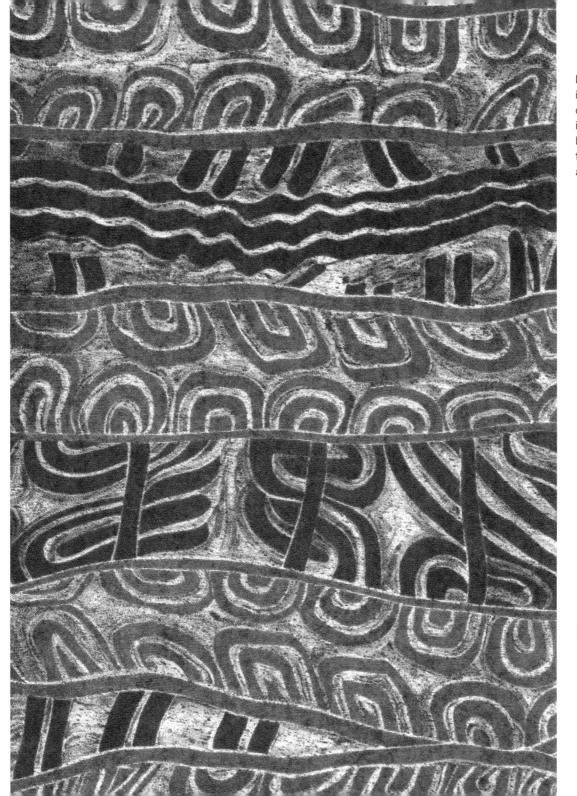

Left: Subject to global influences and drawing on diverse sources for inspiration, this Indonesian, batik-like print by Kenzo is typical of the designer's aesthetic.

Right: A Furphy Simpson print for the British designer Katharine Hamnett, for spring/summer 1983. The design was created using cut paper positioned over brushstrokes.

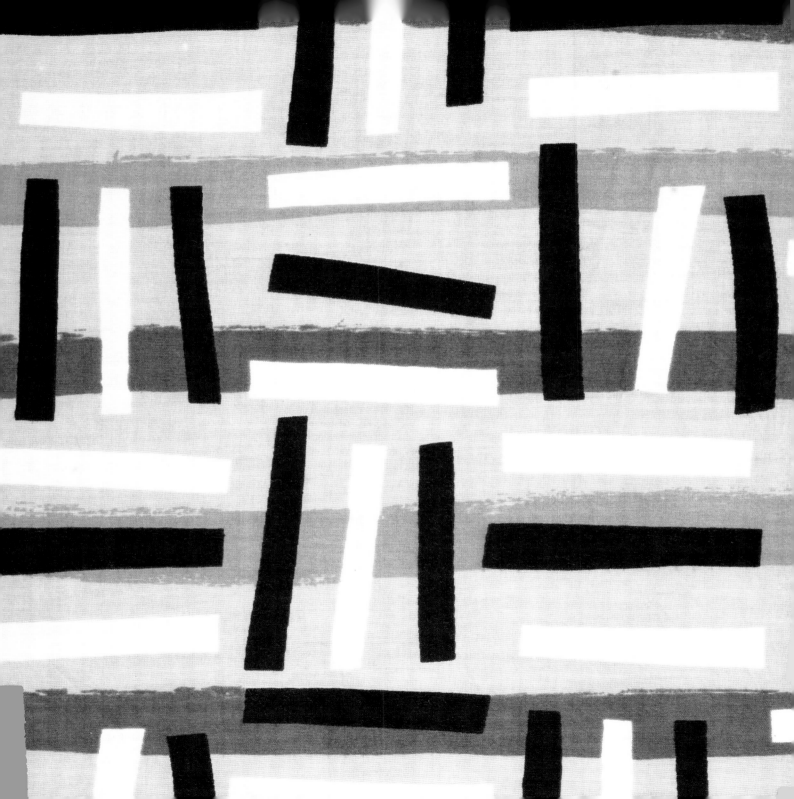

Above: The intricate spacing of a simple dot motif is used to convey the qualities of animal skin in this print design for a Gianni Versace trouser suit.

Right: The 1980s heralded a return to the popularity of the animal print: this bastardized version appeared on a dress by the American designer Diane Fres. The popularity of animal prints such as faux leopard dates from the early nineteenth century, when Napoleon returned to Paris from his expedition to North Africa with real hides. The wearing of animal skins is seen as a desire to convey the same behavioural traits as those of the animals. The spotted coat of the female leopard – the female being the fiercest fighter – is perceived as representing the archetypal femme fatale, implying killer instincts.

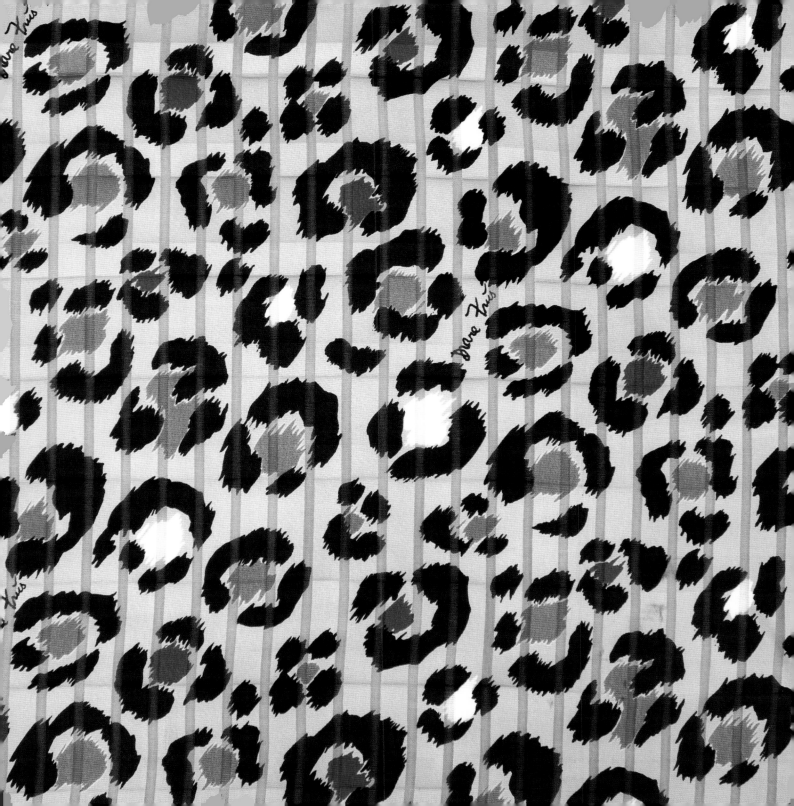

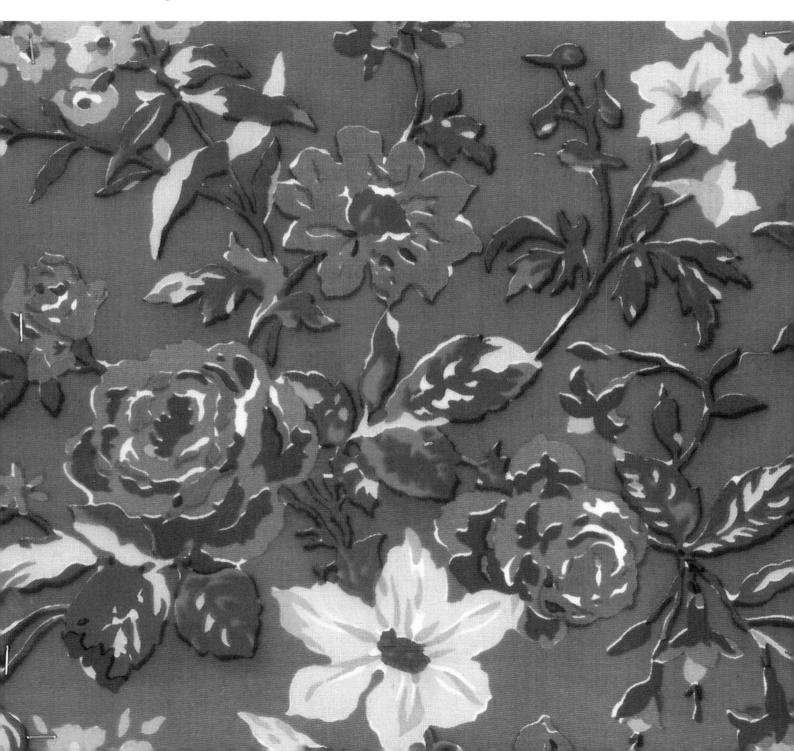

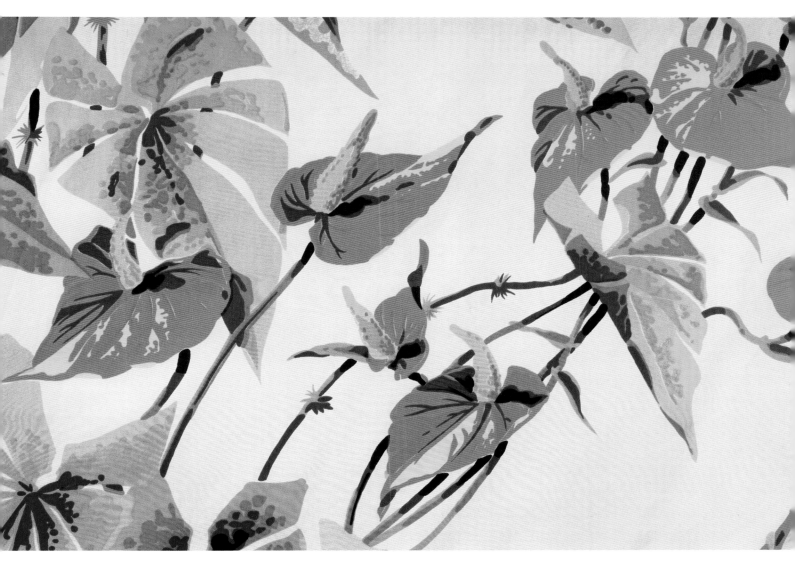

Left: Many of the designs for Liberty, such as this eight-colour print, were readily translated on to challis, a fabric that underwent a revival in the 1980s. Derived from the Indian word 'shale', meaning 'soft', challis is a lightweight wool and silk fabric first produced in Norwich in 1832. It was initially dyed with the aniline dyes based on coal tar, of deep and brilliant colours, invented by William Henry Perkin in 1856.

Above: A simple and tonally harmonious print design on a silk blouse by the American designer Anne Pinkerton.

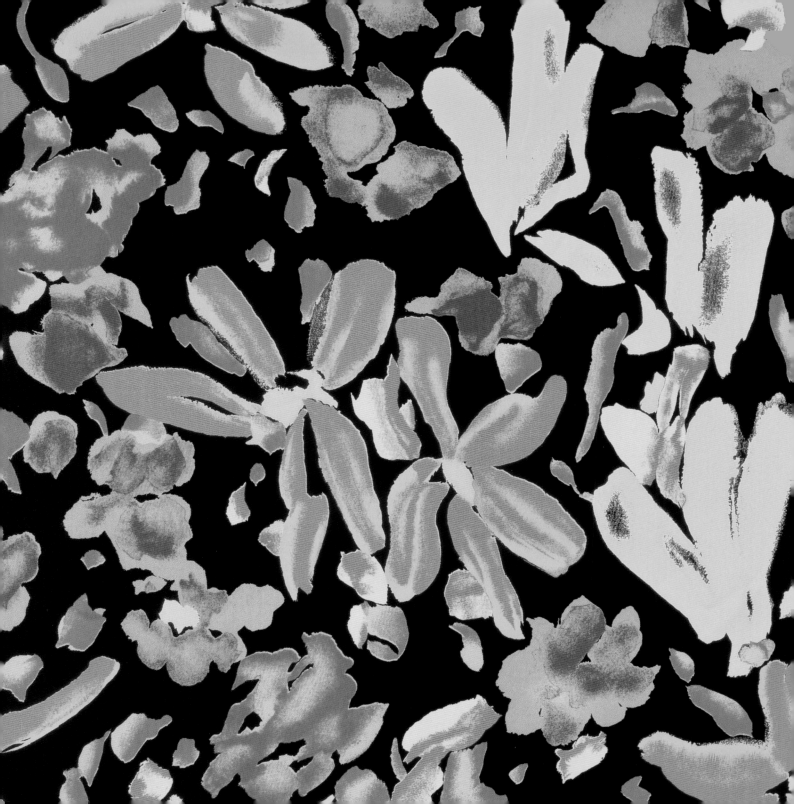

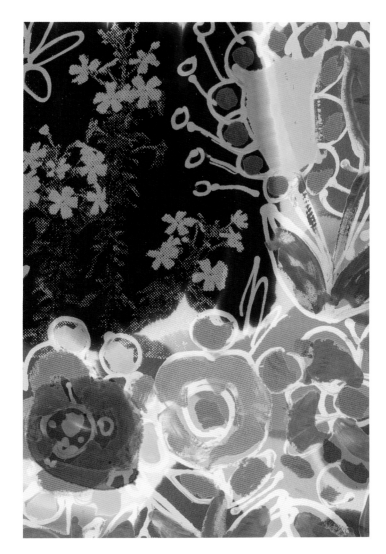

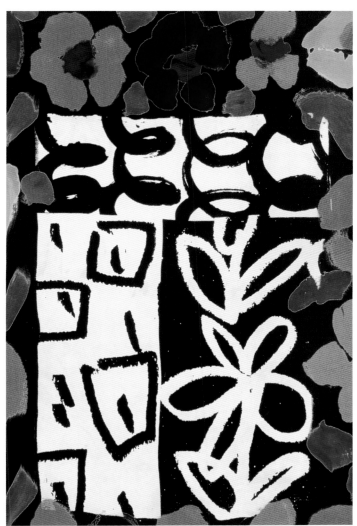

Left: The design studio Furphy Simpson use crepe de Chine like a blank canvas: it was the ideal base for the technique of discharge printing, where the print is actually 'bleached out' of the base fabric.

Above left: Furphy Simpson's expertise and enthusiasm for the discharge-printing technique is demonstrated in this excellent example. Here, the brown background has been discharged back to white. The design partnership worked almost exclusively straight on to the fabric, rather than on paper; this was much appreciated by their clients, who could then cut and drape the sample length on the body.

Above right: Original artwork demonstrating the double-discharge technique by Furphy Simpson.

Right: The design studio Furphy Simpson focused on bright, colour-discharge designs out of dark grounds; far more difficult was to achieve was the complex process of 'darks out of darks'. This deeply sophisticated discharge print demonstrates the dramatic results of the process. The formula was watered down to achieve the 'halo' effect.

Far right: A solidly packed surface of eight intense colours shows the influence of the distinctive geometrized use of florals typical of the style of the Wiener Werkstätte of Austria, a company originally established by Josef Hoffman and Koloman Moser in 1903.

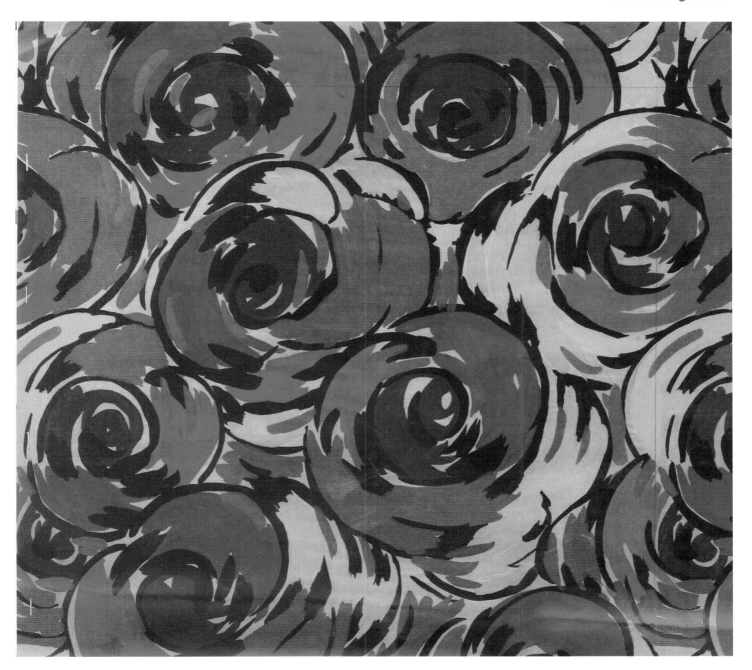

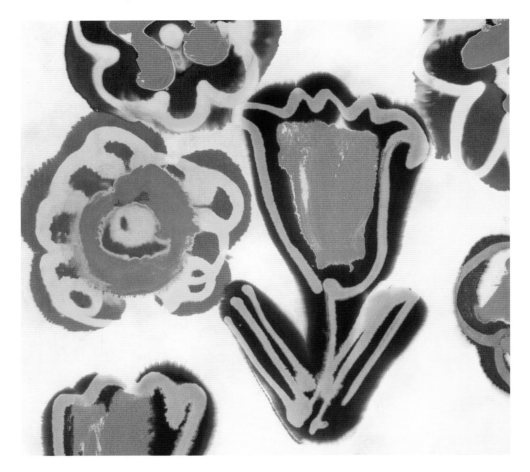

Above: Further examples of the use of a sophisticated discharge technique. Val Furphy of Furphy Simpson states: 'We love using the process so much that we actually discharge the brown background back to white, rather than work directly on a white ground.'

Right: Bold, large-scale discharge print of painterly blooms with a strong, graphic brushstroke.

Left: In this five-colour print by Liberty for the French designer Yves Saint Laurent, torn edges of collaged paper describe naive silhouettes of large daisies. The white background separates the solid areas of colour, keeping the design crisp and fresh.

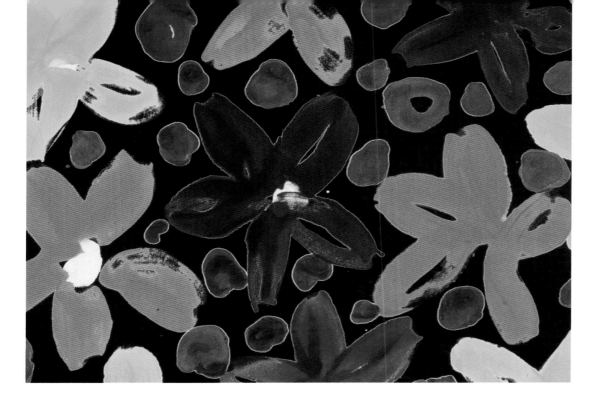

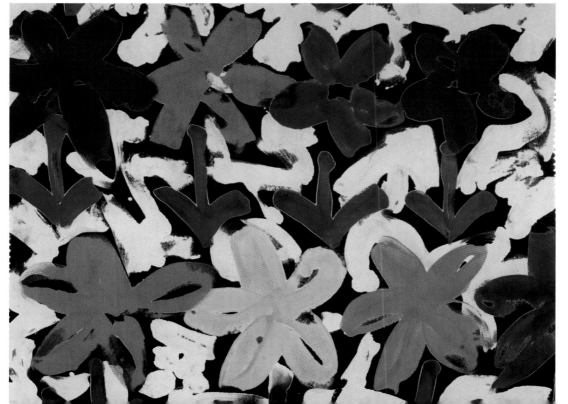

This page: The original artwork for a discharge print out of black crepe de Chine by Furphy Simpson. The final print on the fabric underwent two processes: the white discharge followed by the colour discharge. Consequently, the fabric had to be printed and painted, steamed and washed twice.

Right: The 1980s were a time of experimentation in print design: innovation and unexpected juxtapositions of imagery were accepted by the clients of the design studio Furphy Simpson. The mixed-media techniques in this design include discharge printing and photographic processes.

Far right: The design partnership Furphy Simpson was continually attempting to meet the demand for innovative paisley designs for the winter collections of designers, particularly the Italian label Etro; in summer there was always a request for floral designs. The black-and-white imagery in the centre of this design was printed through a screen that incorporated images from copies of old paisleys and fabric swatches from the designers' previous collections.

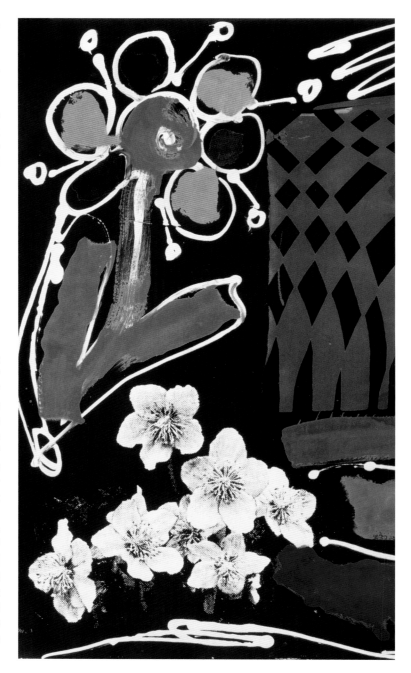

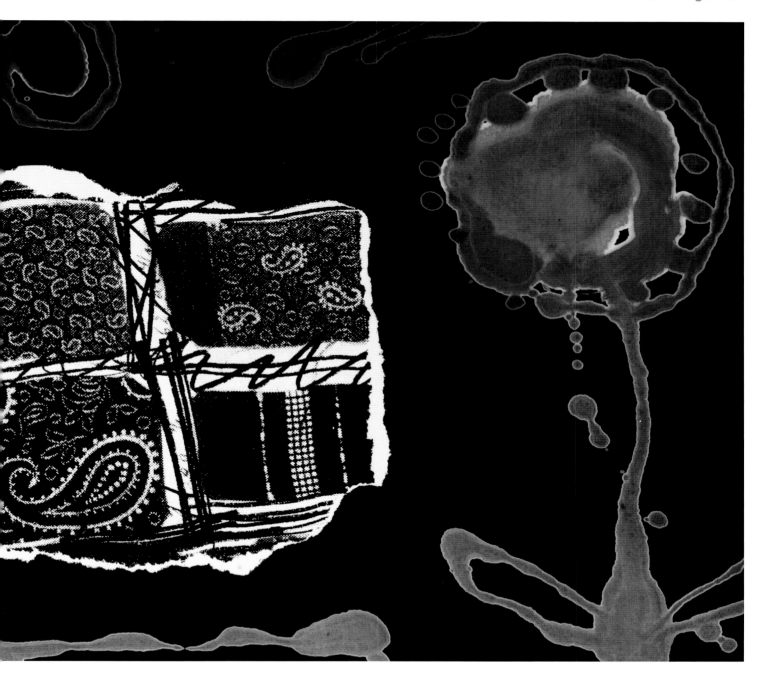

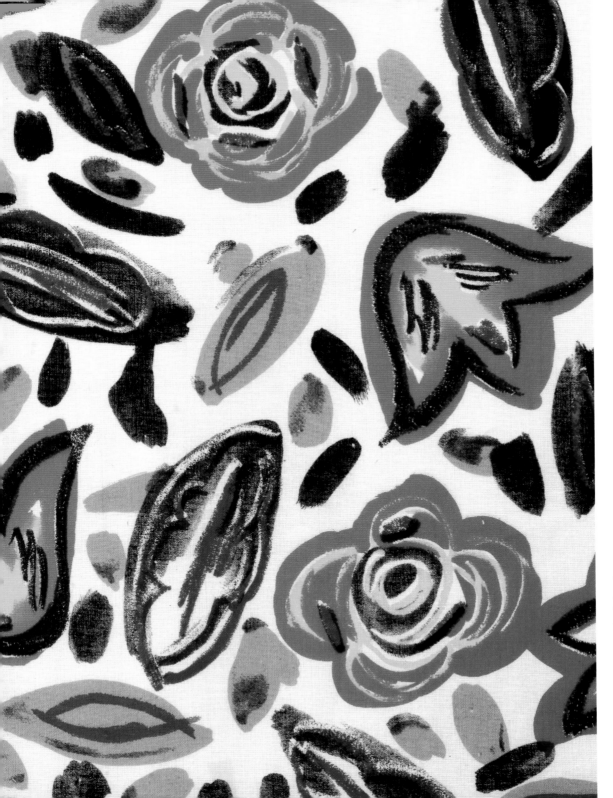

Left and right: This loose, translucent patterning was achieved with dye diluted with water and painted onto watercolour paper; the addition of wax crayon adds definition. Designs by Furphy Simpson, printed by Rhomberg Textiles, on linen-effect cotton.

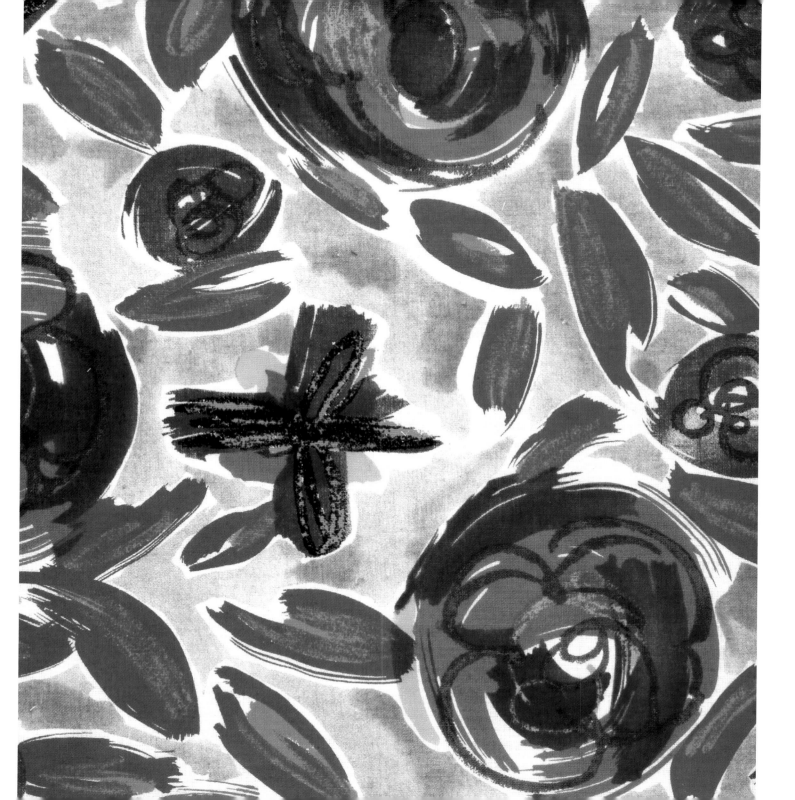

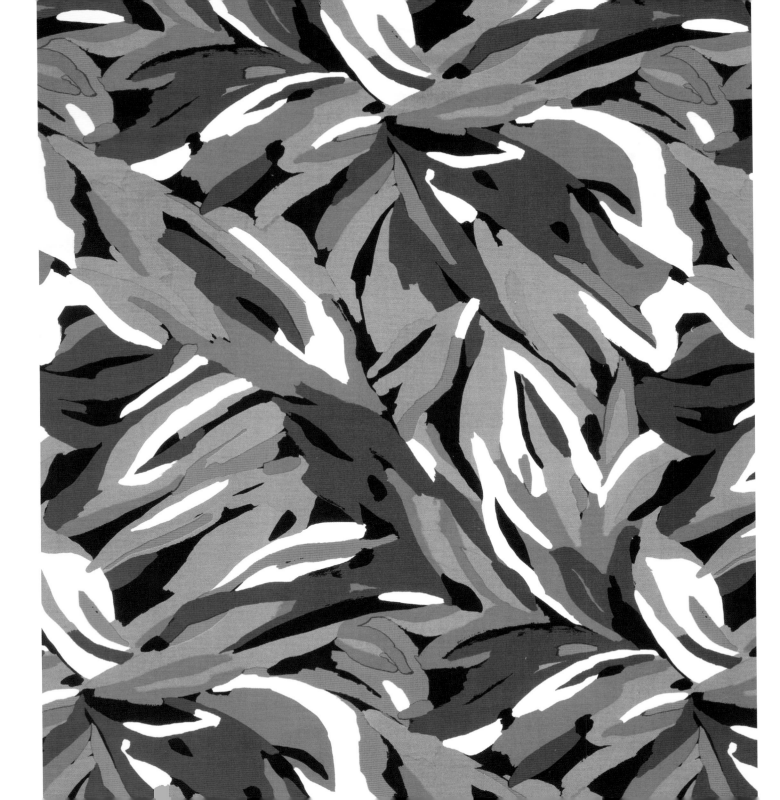

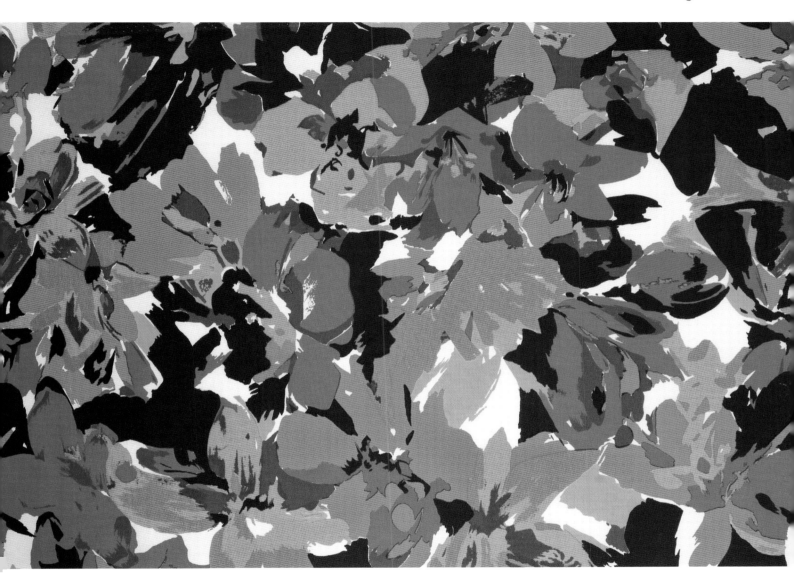

Left: Large-scale repeat
pattern featuring a vortex of
painterly swathes of colour.

Above: Impressionistic floral
print using colours from the
opposite ends of the spectrum
for maximum impact.

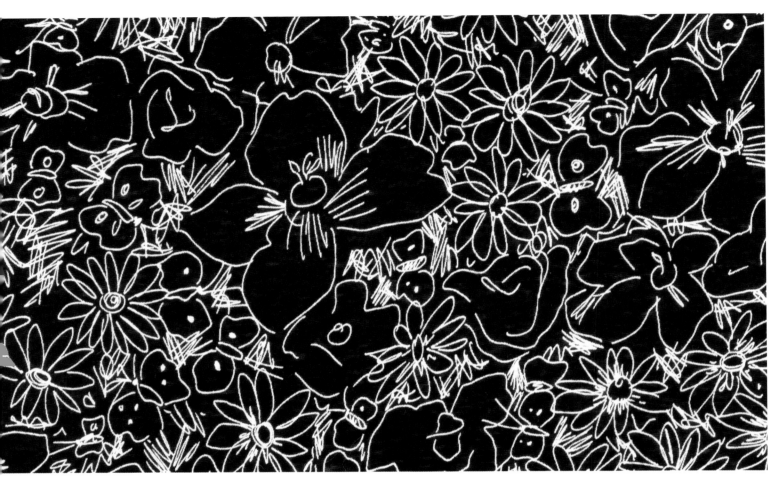

Above and right: Towards the end of the decade, as the minimalist 1990s drew closer, design partnership Furphy Simpson began to concentrate on monotone designs in their signature discharge prints.

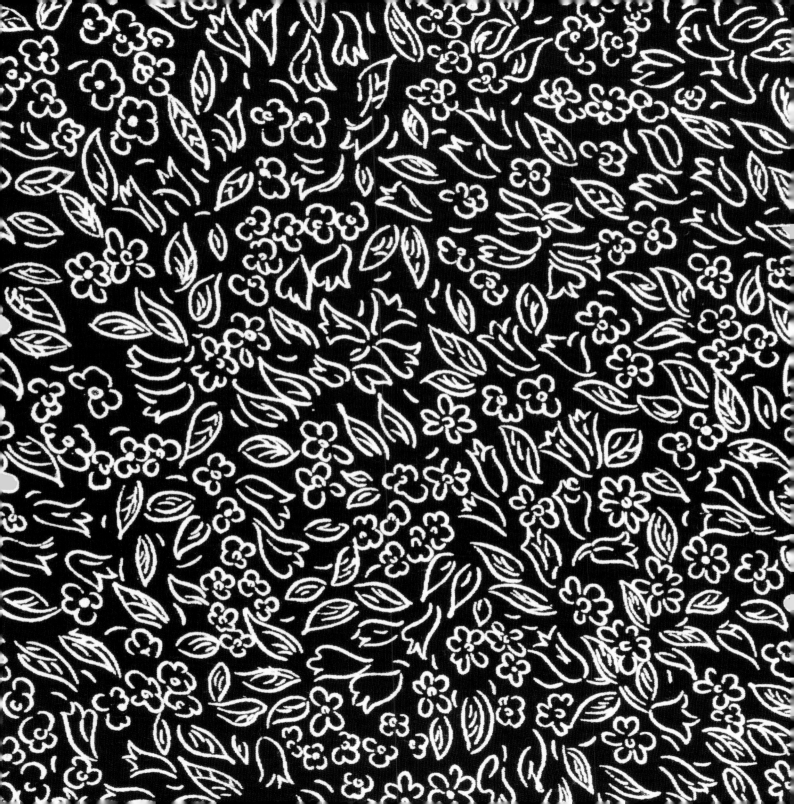

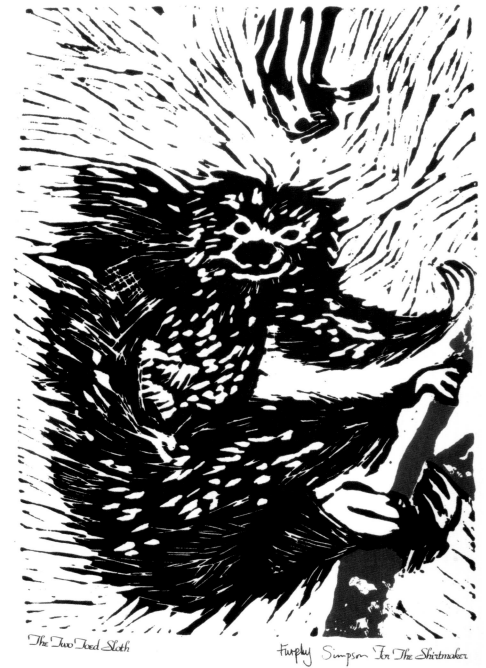

The Two Toed Sloth

Murphy Simpson For The Shirtmaker

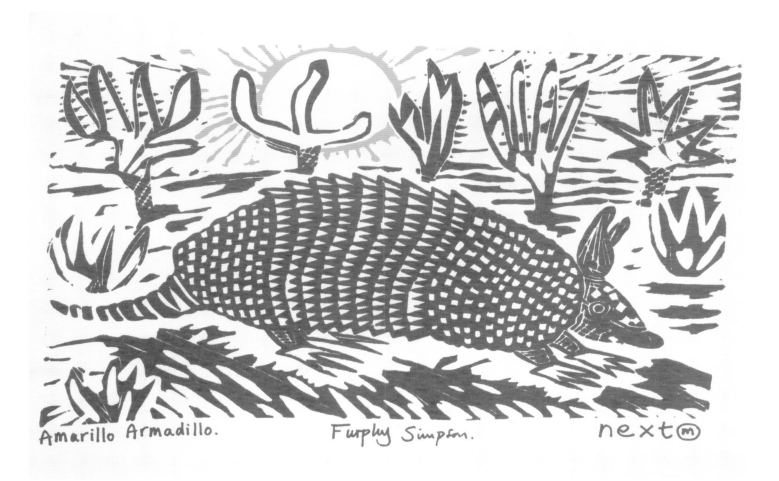

Amarillo Armadillo. Furphy Simpson. next Ⓜ

Left and right: Two linocut prints designed by Furphy Simpson, a technique they still favour today. *Sloth* was sold to The Shirtmaker, and *Armadillo* to the high street clothing chain Next.

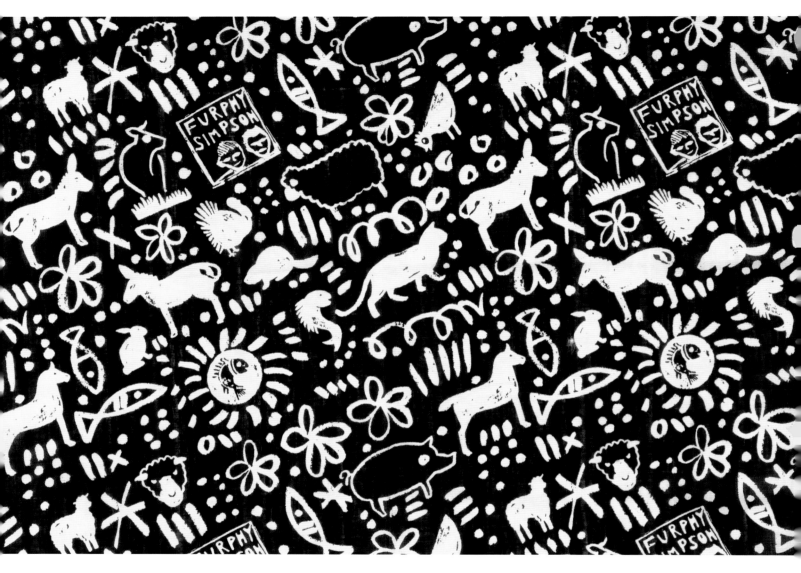

Above and right: Two handkerchief designs by Furphy Simpson for a Japanese label. The company's name is incorporated into the design.

Left: *Zeebak*, a furnishing fabric inspired by Native American motifs, by Liberty.

Right: Stripes of various widths form the basis of this checked design by Furphy Simpson, the ethnic feel of which is further reinforced by the earthy tones of the colour palette.

5 RADICAL CLASSICAL

Classicism is the artistic movement concerned with those qualities considered to be characteristic of the Greek or Roman style, such as reason, discipline, restraint, order and harmony. In the 1980s, these were subverted by designers who playfully deconstructed historical motifs in a way that retained all the grandiosity of the original but none of the reverence. The appropriation of engravings of classical statues and antique architectural details was a particular feature of print design in an era preoccupied with formal glamour and the 'designed' interior. The foremost exponents of this sampling of historical motifs were artist Sue Timney and textile and graphic designer Grahame Fowler, of the design company Timney Fowler. Graduates of London's Royal College of Art, this print duo revisited the past for their neo-classical collection of furnishing fabrics in 1983, with dramatic, large-scale designs entitled *Columns* and *Roman Heads*. Their reaction against the romantic included a striking absence of colour in their earlier work, the black-and-white images translating effectively onto garments.

Right: Shirt design by Timney Fowler: *Target Dollar*, printed on crepe de Chine.

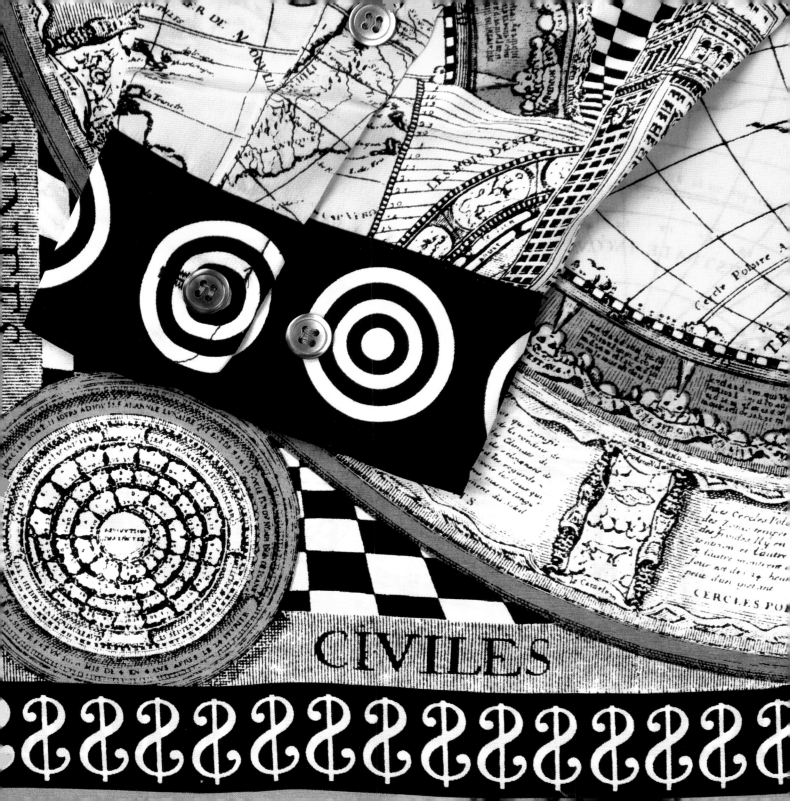

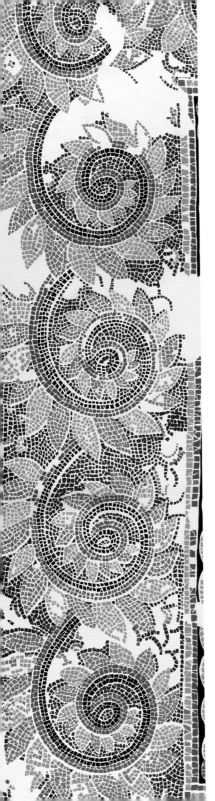

The 'big shirt' was a particular feature of the 1980s. Similar in silhouette to the loosely cut T-shirt and worn over leggings or a long, narrow skirt, the big shirt was the perfect canvas for those print designers who liked to work to a large scale. The shirt was cut to take full advantage of the print design, with the width of the fabric correlating to the width of the shirt. The shaping of side seams and darts were eschewed in favour of a careful placement of the design to acknowledge the full beauty and complexity of the print. Borders were used for the centre front fastenings and the cuffs of the sleeves.

British print practitioners English Eccentrics also featured the big shirt in their fashion collections. With a name derived from the title of a book by Edith Sitwell, the design company made their first foray into commercialism in a shop called Academy, sited in that bastion of the British avant-garde, the King's Road in London. The company, comprising Helen Littman (now David), her sister Judy and fashion designer Claire Angel, produced fashion collections from 1984 to 1988, eventually opening a shop at London's Brompton Cross. The textile designs were screen-printed by hand; a single print design could combine flat printed screens, outline screens, textured screens and photographic screens, with a different screen made for each colour.

The luminosity and strength of the colour was the result of using acid dyes instead of the more customary opaque dyes, a difference very much like that between the transparency of watercolour and the opaqueness of gouache. Gouache (water-soluble paint) is the traditional medium of the textile designer because of its similarity to the look of textile dyes. A post-modern narrative runs through all the designs; sources come from subjects as diverse as medieval England, astrology and the work of the Austrian psychoanalyst Sigmund Freud. All indicate the enthusiasms and preoccupations of the designer, and all contain eclectic juxtapositions of imagery and motifs used with an ironic knowingness.

Bohemian luxury mediated through luscious textures, baroque patterning and rich colours is the signature of the design label Georgina von Etzdorf. Etzdorf studied textile design at Camberwell School of Art and in 1981 started her eponymous company with two friends, Jonathan Docherty and Martin Simcock. Etzdorf first used the velvet for which she is renowned in 1985, dyeing and printing the rayon, cotton and silk velvets by hand as if they were a canvas, exploiting the fabrics' surface pile to produce changing depths of colour, movement and texture. Inspiration lay in translating various aspects of the natural world, attempting to define light and mood rather than tell a story, or in the demands of rendering pure abstraction in vibrant, saturated colour.

Very much in the tradition of artists such as Sonia Delaunay and Raoul Dufy, Georgina von Etzdorf transmuted art into fashion. Every design has its provenance in a painting executed in watercolours, gouache or chalk. In tune with the British Arts and Crafts movement at the beginning of the twentieth century, the craft process, for the designer, was of vital importance: exploring all aspects of the design process from fabric choice to making the screen, applying the dye and plotting repeats.

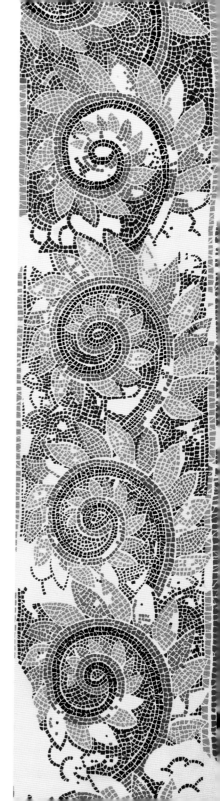

Left and right: A design based on the work of Antonio Gaudí by Helen David of English Eccentrics, 1985.

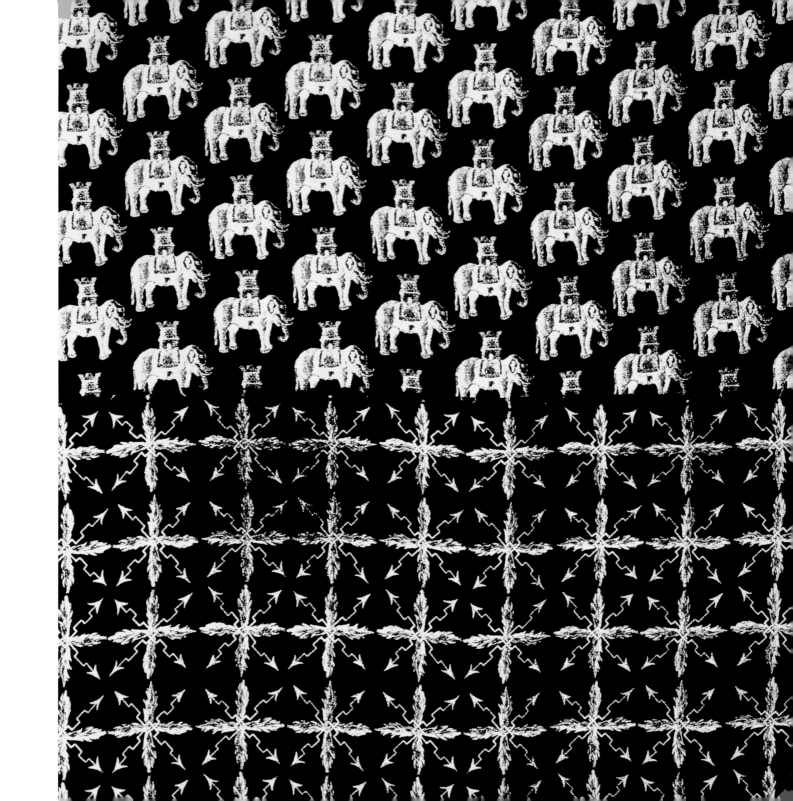

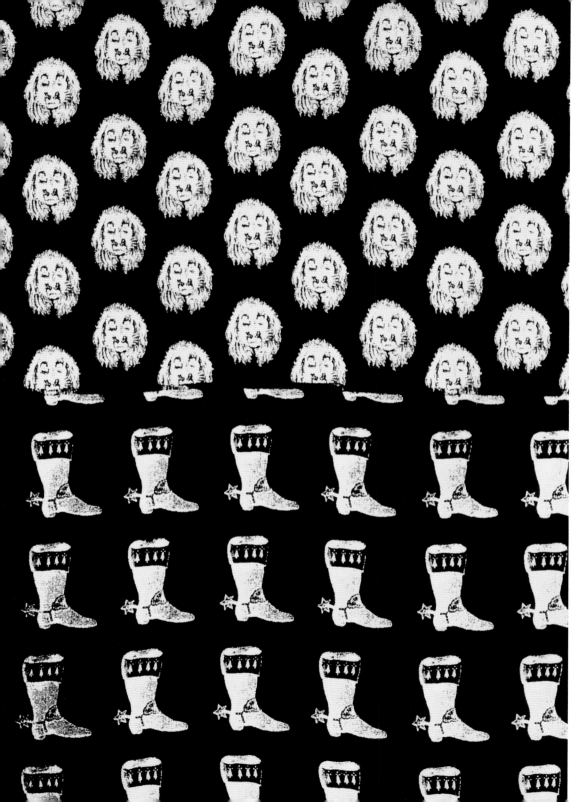

Left: Boots, elephants, lions and arrows by Timney Fowler, printed on crepe de Chine.

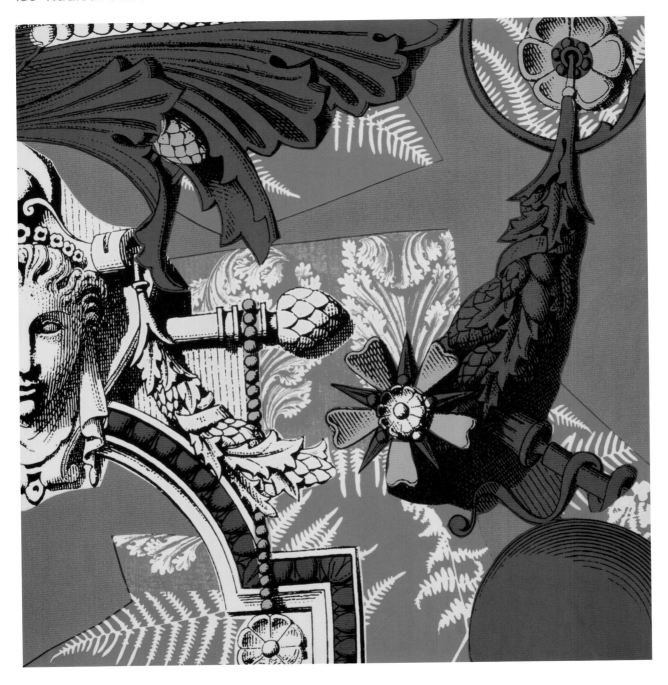

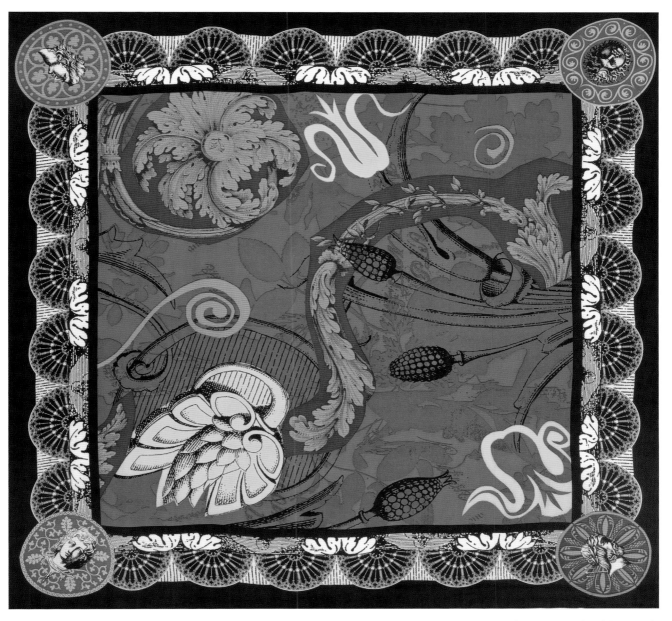

Celebration (left) and *Bocage* (above) by Timney Fowler. Classical meets modern in this clash of colours and architectural details, printed on crepe de Chine.

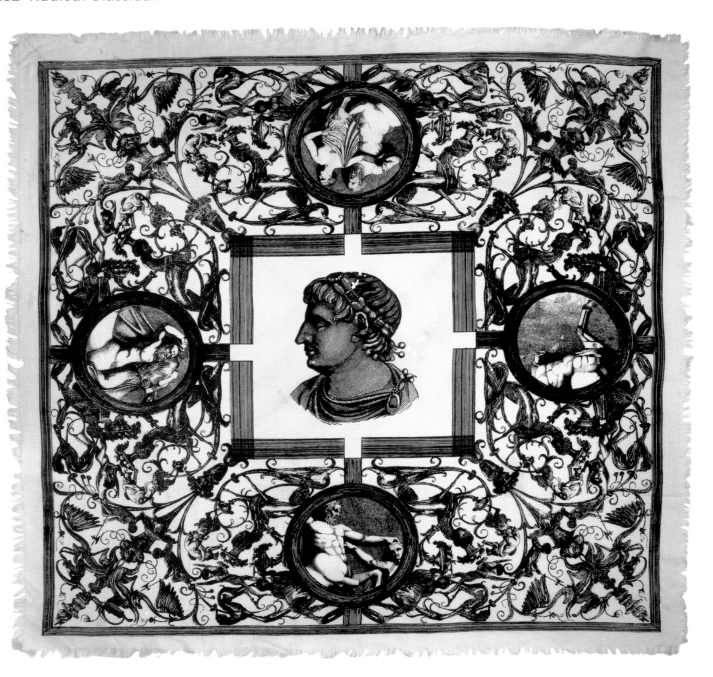

Left: This classical design by Timney Fowler, *Nero*, printed on wool challis, incorporates roundels of mythological creatures inspired by the spirit of late Renaissance Mannerism, with its notably intellectual sophistication as well as its artificial (as opposed to naturalistic) qualities.

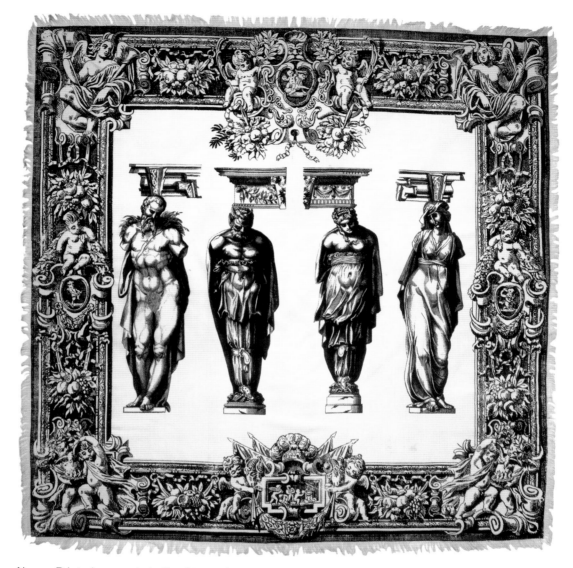

Above: Printed on wool challis, *Statues* is another classically influenced design by Timney Fowler. The statues – *kouroi* (male) and *korai* (female) – are in archaic Greek style, surrounded by a classical frieze (with shields and strapwork). The statues depict clothed priests and priestesses, gods and goddesses, each with the typically archaic thin-lipped smile.

Left: *Astronomy*, printed on crepe de Chine by Timney Fowler. The design measures 109 x 109cm (43 x 43 in).

Right: An eighteenth-century engraving of the pyramids is juxtaposed with hieroglyphic details from inside Egyptian tombs in this design, *Sphinx*, on crepe de Chine by Timney Fowler.

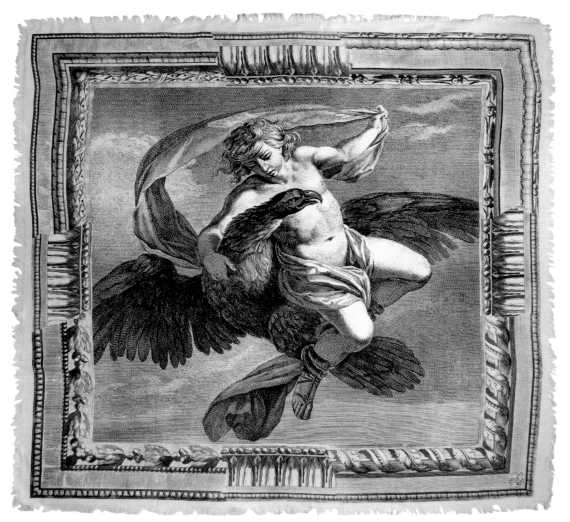

Right: *Pastoral* by Timney Fowler, printed on wool challis. A floral border surrounds three female figures in a classical Arcadian scene. The female figure carrying a basket of flowers may represent either Flora (the goddess of spring) or abundance.

Above: Sue Timney and Grahame Fowler utilize Greek mythology in this design, *Ganymede*, printed on wool challis. The scene depicts the messenger of Zeus, the eagle Aetos Dios, carrying the handsome youth Ganymede to heaven. The design measures 132 x 132cm (52 x 52 in).

Left: *Laurel* by Timney Fowler, printed on crepe de Chine. Two classical busts – one male, one female – float inside a border which has a motif of Roman laurel leaves.
Below left: Detail from the cuff of the shirt.

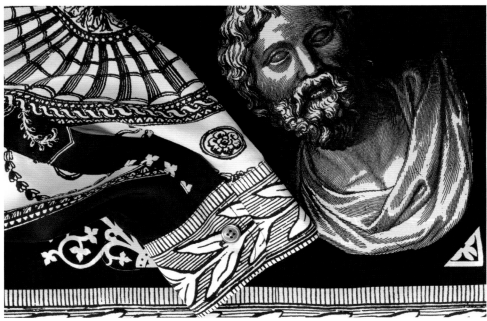

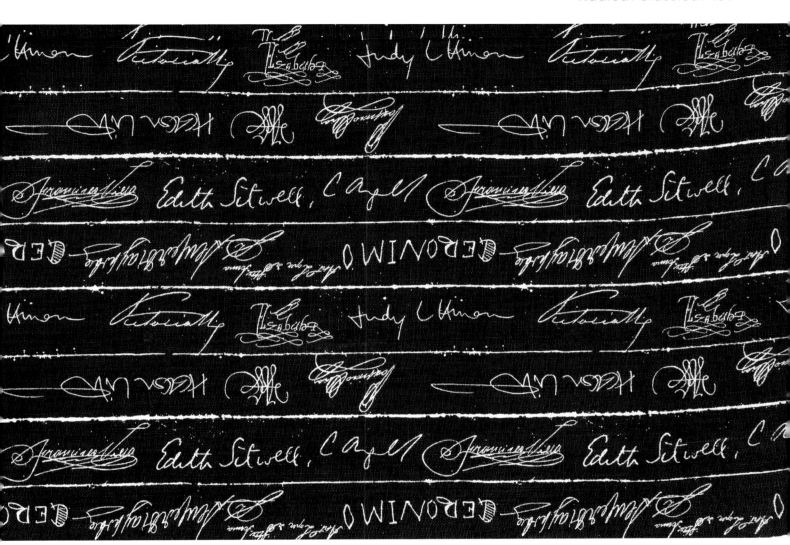

Above: Flamboyant signatures of well-known people combined with those of the English Eccentrics design team make up *Signatures*, designed in 1985 and printed on 90cm (36in) linen and 90cm (36in) silk twill.

Above: *Omega*, a cotton furnishing fabric designed by Conran in 1987, reflects the resurgence of interest in the Omega Workshops, founded by Roger Fry in 1910. Closely associated with the Bloomsbury Group, leading artists Vanessa Bell and Duncan Grant explored the decorated surface, from furniture and textiles to glass and ceramics, in a style that loosely referenced the artistic movements of the day, such as Cubism.

Right: Collaged paper, overlaid with brushstrokes and finely drawn lines by Gillian Fellowes, provides evidence of inspiration from diverse sources, including a bust of Nefertiti and a vase of flowers inspired by Art Deco.

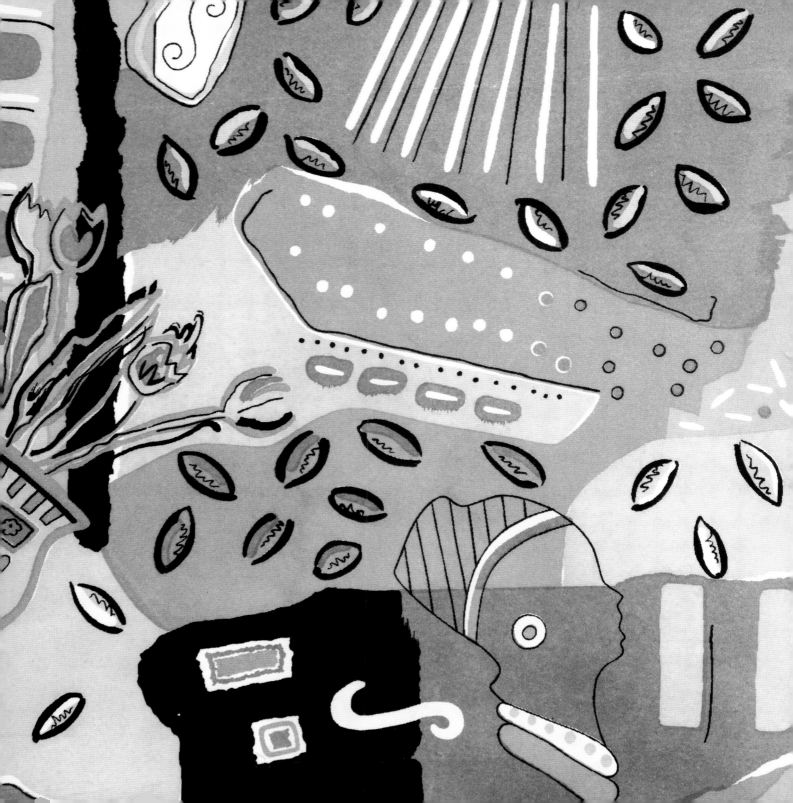

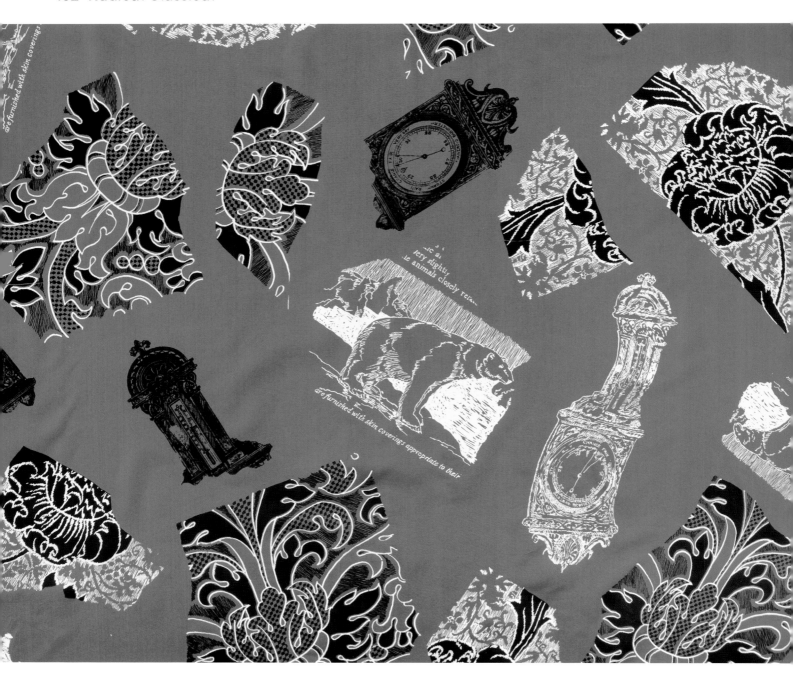

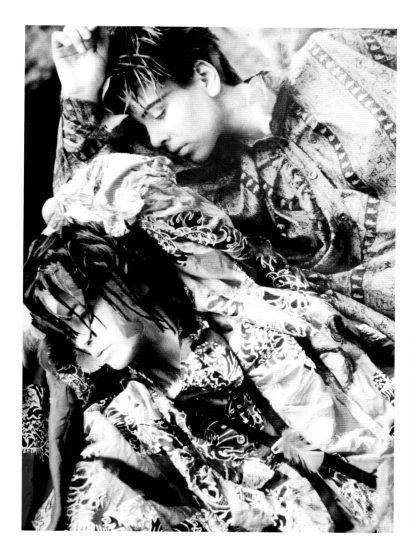

Helen David's idea for her 'Arctic' collection was the result of a journey to Tokyo in 1984, when the plane made a refuelling stop in Alaska. She recalls, 'A giant stuffed polar bear in a glass case at Anchorage airport caught my eye. I thought about the Arctic explorers, and the drive which compelled them to leave the comfort of their Victorian drawing rooms for the extreme conditions of the Arctic Circle. These images suggested the "Arctic" design. My first attempt was based on Victorian wallpaper, but looked too formal. I decided to tear up my original, adding barometers distorted on the photocopier.' The design was printed in pigment dyes on 90cm (36in) silk habotai and silk organza in two colours and five colourways. The repeat size is 89 x 90cm (35 x 36in).

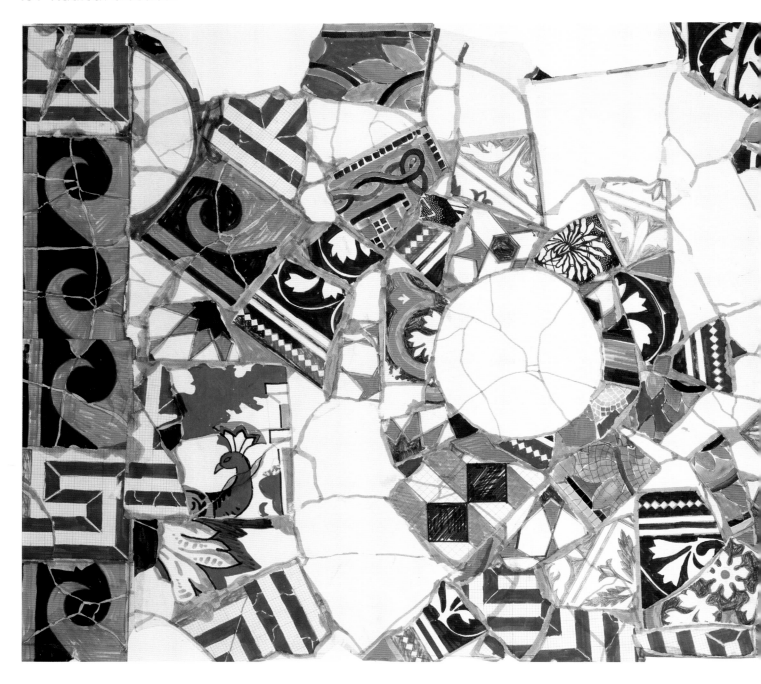

Right: Helen David's original artwork which formed the basis of the 'Gaudí' collection by English Eccentrics. The designer had long been an admirer of the work of Antonio Gaudí, with his deployment of organic form and vibrancy in mosaic surface decoration.

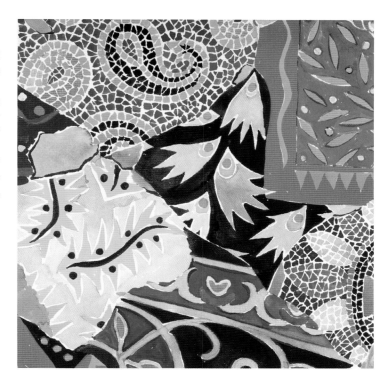

Left and right: The 'Gaudí' collection, from the summer of 1985, features images from the watercolour paintings of Helen David juxtaposed with fragments of classical architectural diagrams. Printed on 90cm (36in) silk habotai in four colours and five colourways with pigment dyes, the repeat size is 50.5 x 90cm (19¾ x 36in).

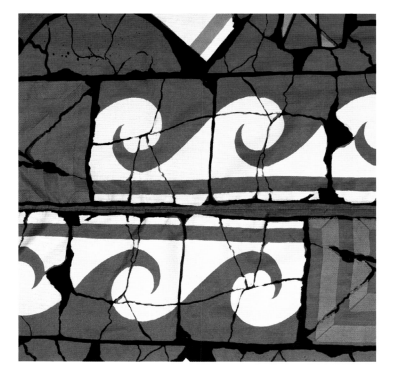

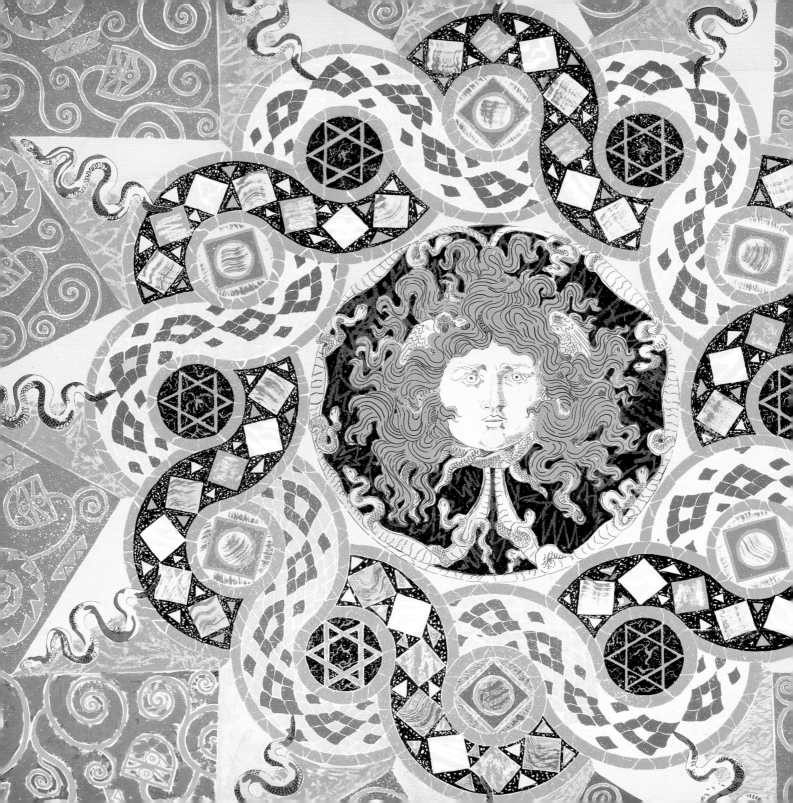

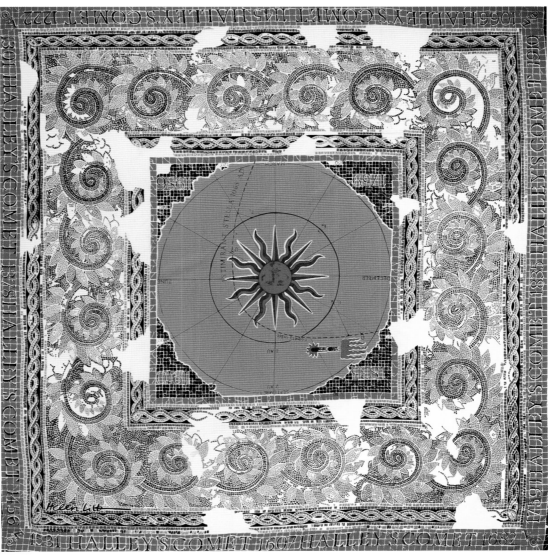

Left: *Medusa*, designed by English Eccentrics in 1987, was printed with acid dyes on 114cm (45in) crepe de Chine, one of a series of designs that attempted to engage with the 'feminine principle'.

Above: In 1986, Halley's Comet made a reappearance in the skies for the first time in seventy-five years. To commemorate this, Helen David of English Eccentrics created a design depicting the comet and the sun surrounded by images of fragmented mosaic.

Right: A stylized elephant and a horse, richly textured with surface decoration, are depicted within two decorative circles on a black background in this design by Helen David of English Eccentrics.

Left: The colours and patterns found in the interiors and national costumes of Thailand inspired *Thai Flowers* by Helen David of English Eccentrics. Designed in 1988 and printed with acid dyes on 114cm (45in) Thai silk, the print appeared in three colours and four colourways. The repeat size is 35 x 35cm (13¾ x 13¾in).

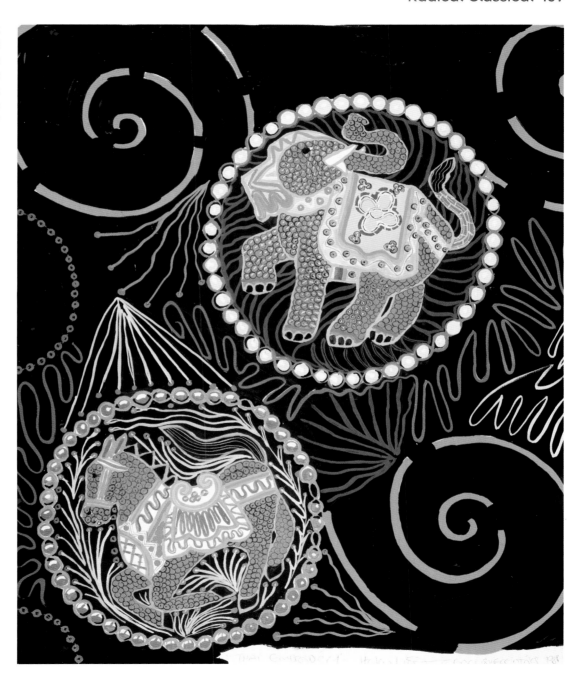

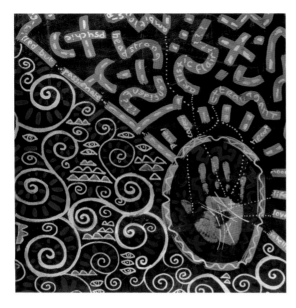
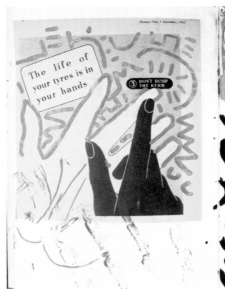
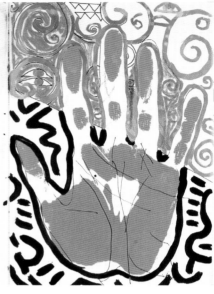
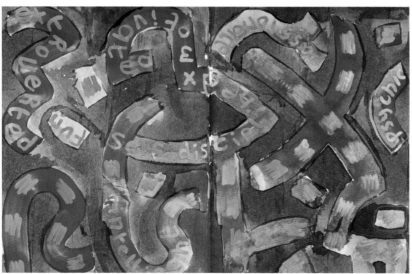
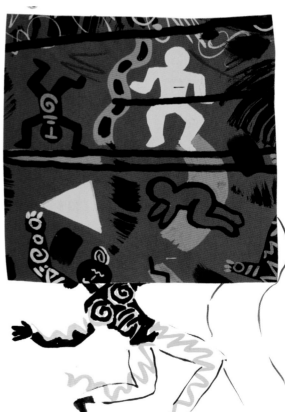

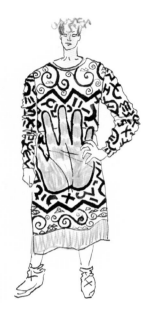

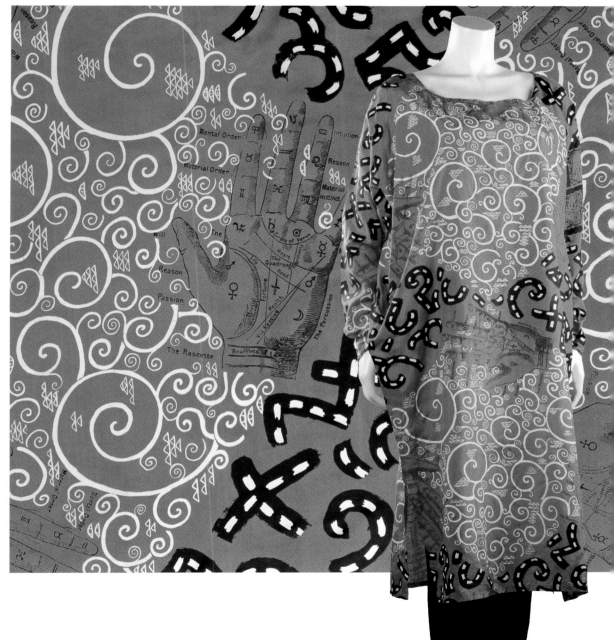

A series of images charting the progress of a design from initial idea through to realization, including sketchbook development and the final printed fabric and garment. The 'Hands' collection is one of English Eccentrics' most well-known collections, and was inspired by Helen David's trip to New York. The urban graffiti she saw there, and Manhattan's palmistry parlours, are juxtaposed with a spiral pattern based on Gustav Klimt's *Tree of Life*. Preparatory sketches use the designer's own handprint, in combination with graphics inspired by Keith Haring.

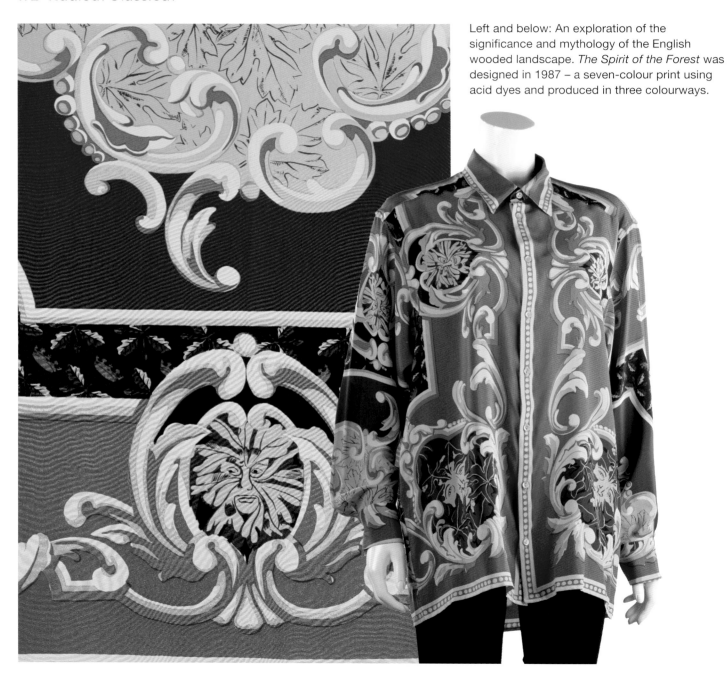

Left and below: An exploration of the significance and mythology of the English wooded landscape. *The Spirit of the Forest* was designed in 1987 – a seven-colour print using acid dyes and produced in three colourways.

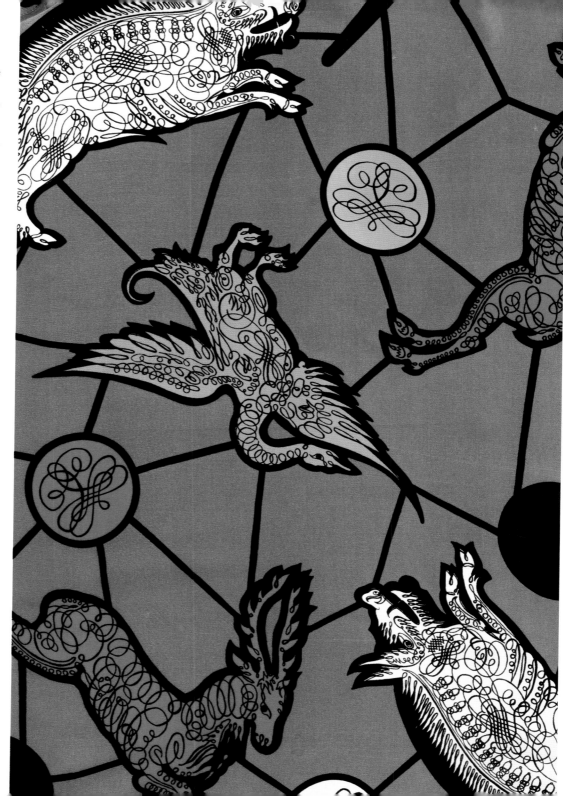

Right and below: The 'Beasts of England' collection features traditional heraldic animals such as swans, harts (famously the emblem of Richard II), wild boar and the mythical unicorn, arranged in front of heavy black lines suggestive of stained glass. It was designed by English Eccentrics in 1987 and was printed with acid dyes on 114cm (45in) wool challis and 114cm (45in) crepe de Chine. The design contains six colours and came in six colourways; the repeat size is 79 x 114cm (31 x 45in).

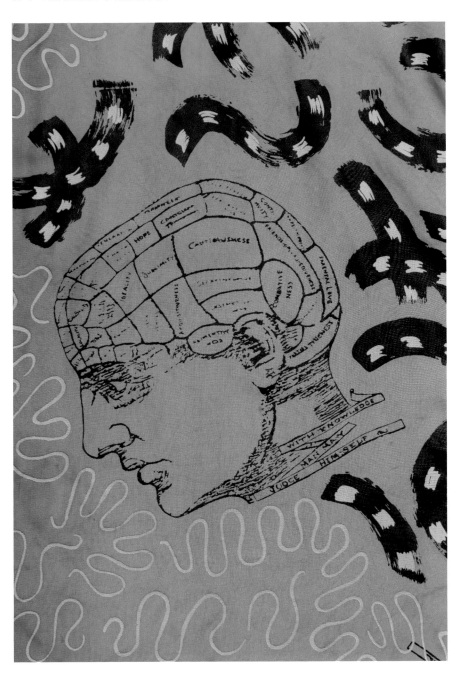

Left: *Heads*, a companion piece to *Hands*, juxtaposes a phrenology diagram with an Indian-inspired border and paisley forms. It was designed by Helen David in 1984 and printed with pigment dyes in three colours on habotai silk. The repeat size is 60 x 90cm (24 x 36in)

Right: Inspired by the work of Freud and Klimt, *Brainwaves* was designed in 1986 by English Eccentrics. Brain waves are suggested by spiral forms, and the diagrammatic motifs come from a drawing by Freud, which attempted to analyse the process of sexual attraction. It is printed in pigment dyes with a single screen on 114cm (45in) cotton poplin. The repeat is 38 x 32cm (15 x 13in).

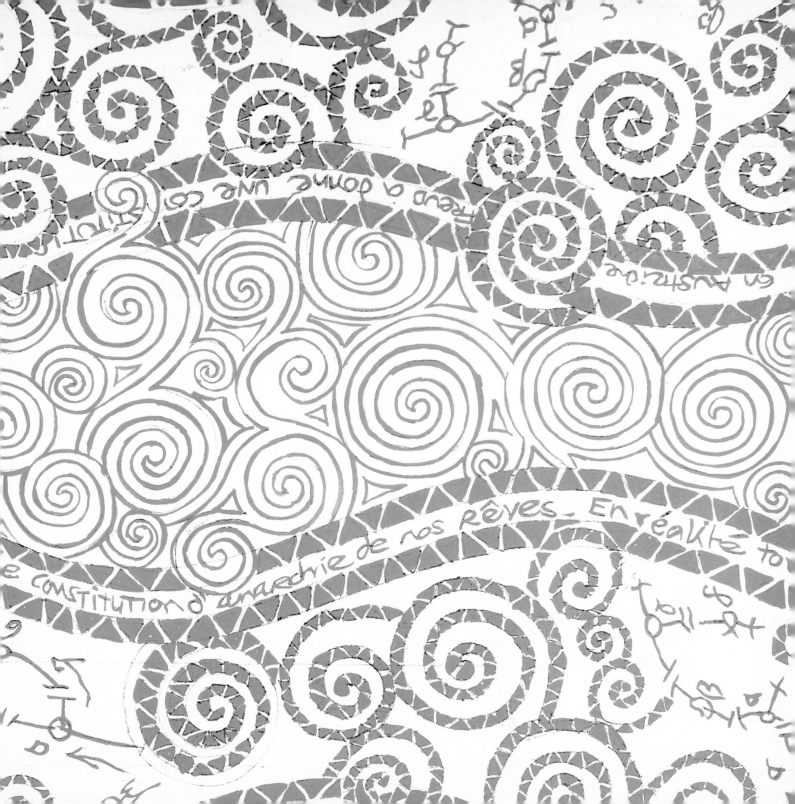

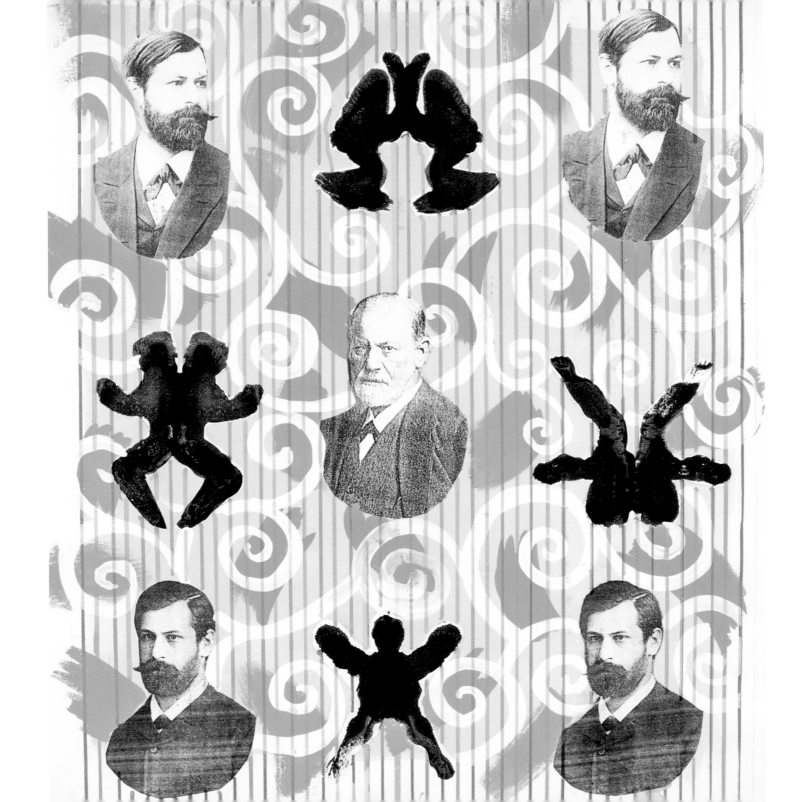

Left: Initial sketchbook work in mixed media for the 'Freudian Slips' collection of 1987 by Helen David. The final three-colour design was printed with acid dyes on habotai silk in three colourways. The repeat was 71 x 57.5cm (28 x 22½in).

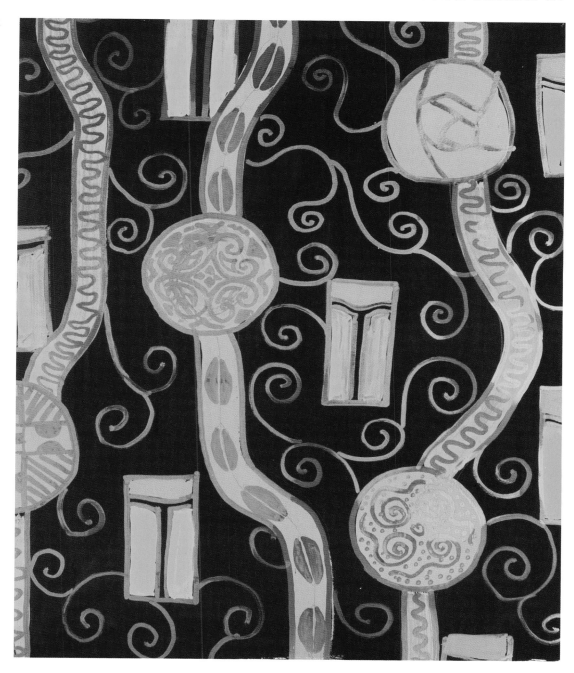

Right: Artwork for aspects of the 'Klimt' collection by Helen David of English Eccentrics.

Left and right: A series of preparatory artworks for the 'City of Monsters' collection, a comment on aspirational 1980s consumerism. The designer, Helen David, explains, 'The square mile of the City of London has its boundaries marked by carved stone monsters, somewhere between dragons and griffins; they hold the shield of St George. Inside the City are monsters of a different kind: stockbrokers, money-dealers, commodity brokers.'

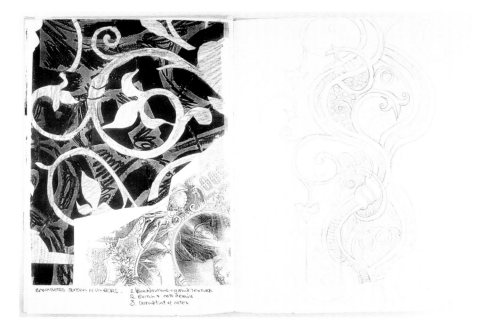

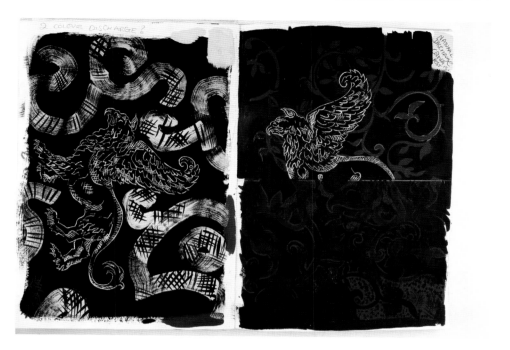

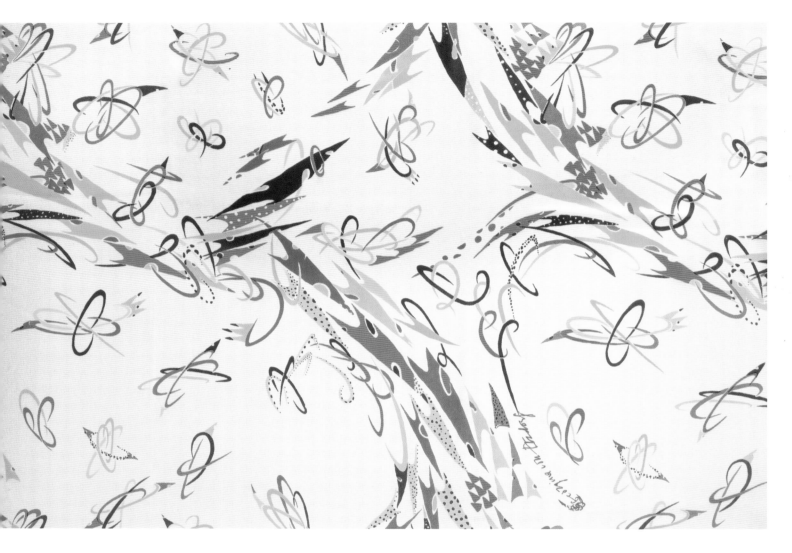

Above: Georgina von Etzdorf relished the challenge of designing on difficult fabrics, including suede, mohair, fur, bouclé, tweed, metallic silk and bi-elastic velvet (which distorted patterns). The 'Star Wars' collection of shooting stars printed on silk chiffon was the first Georgina von Etzdorf design to be featured on the cover of British *Vogue,* in 1981.

Right: Georgina von Etzdorf's interest in the planets and the stars of the night sky provided inspiration for several collections, including 'Eclipse', 'Meteor', 'Star Wars', 'Apollo', 'Jupiter', 'Rockets' and this design, from 'Comets'. The design is reverse-printed, giving the effect of a woven base fabric.

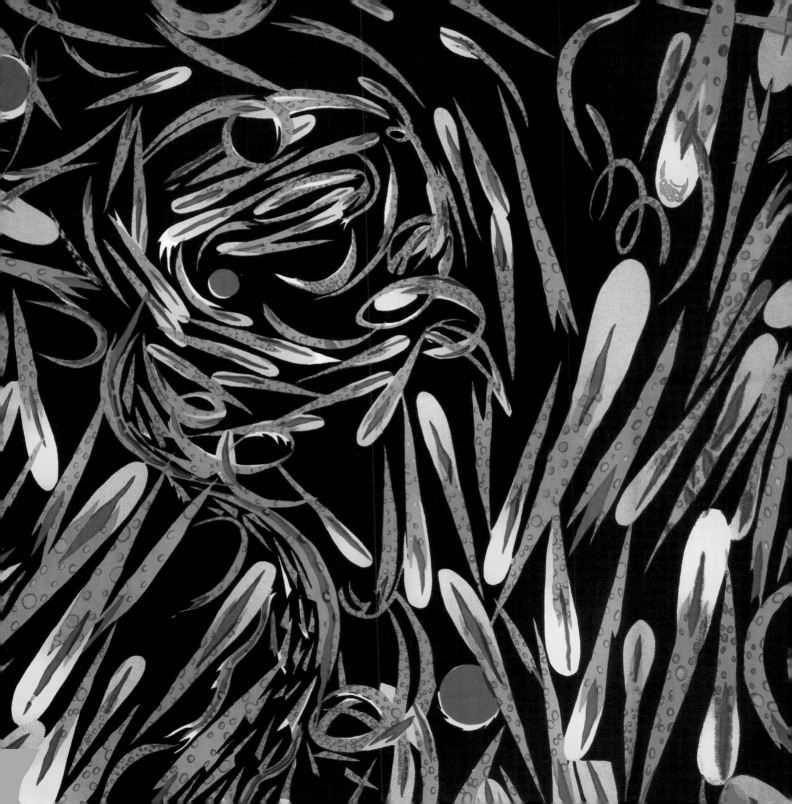

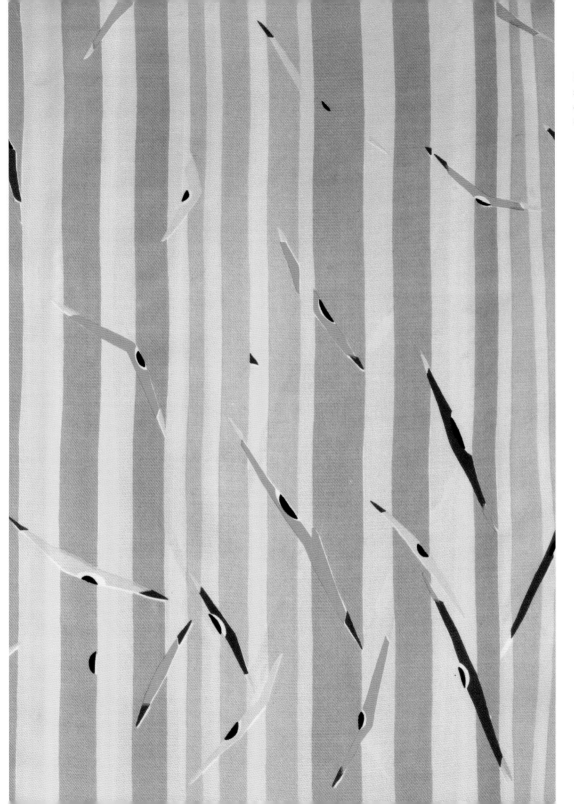

Left: *Quills*, a deceptively simple screen-print design on silk crepe de Chine by Georgina von Etzdorf.

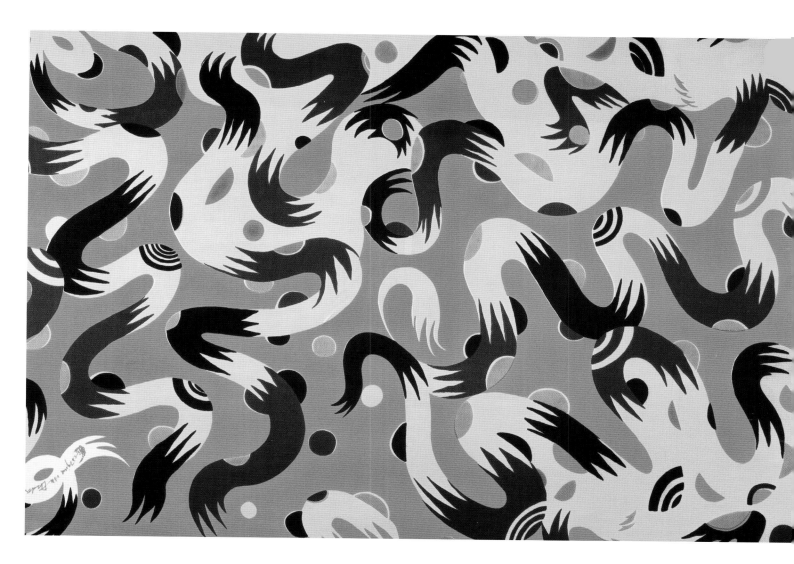

Above: Georgina von
Etzdorf's seamless and fluid
design, *Dragons*, features
rippling dragons' tails printed
on silk crepe-back satin for
spring/summer 1984.

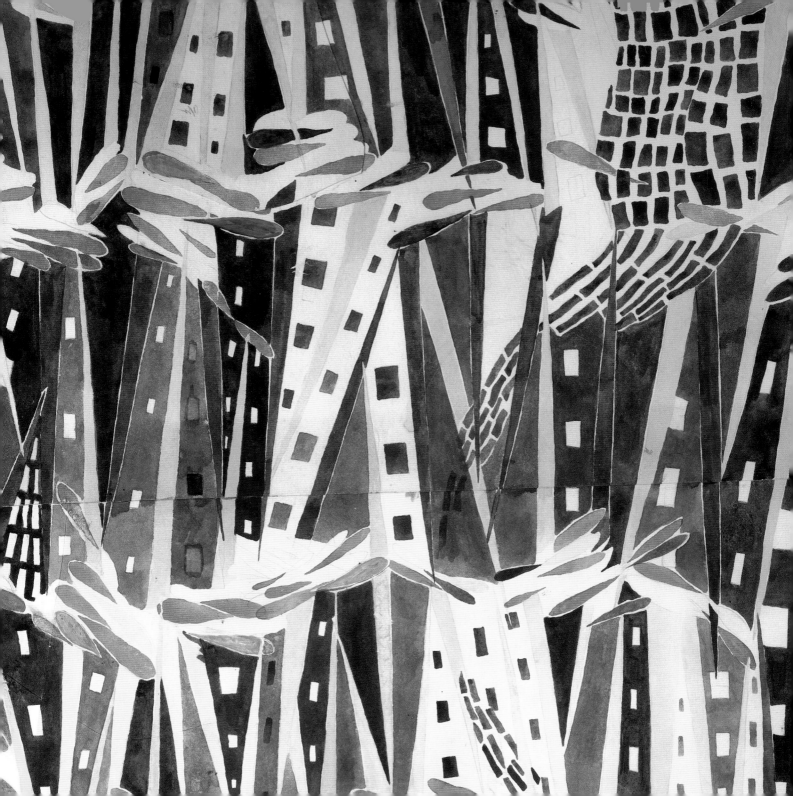

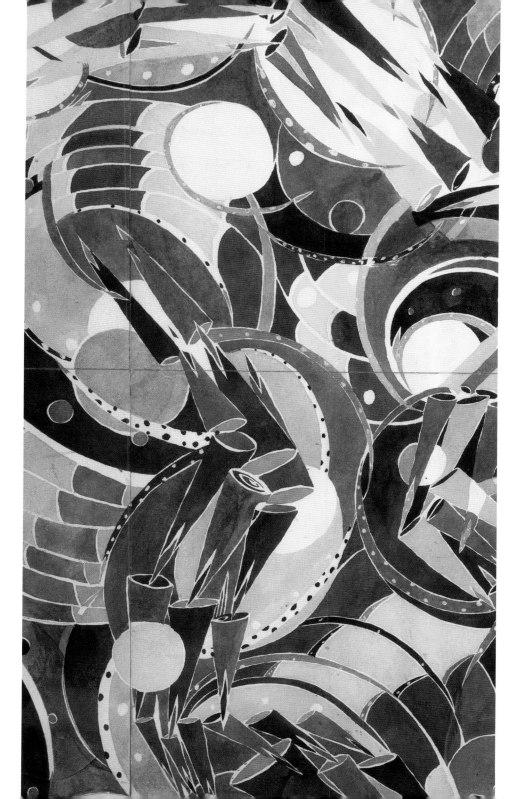

Left: *Metropolis*, a five-screen design for a men's wool scarf by Georgina von Etzdorf in 1981, is an example of the designer's ability to break out of the constraints of traditional repeat methods to create unexpected and quirky diversions along the length of the cloth.

Right: This multi-directional repeat pattern, *Wurlitzer*, was designed by Georgina von Etzdorf in 1984.

Right: Fish-like shapes float across the surface of an off-white circle, in this design, *Moonfish*, by Georgina von Etzdorf.

Far right: *Faites Vos Jeux* by Georgina von Etzdorf. Manufacture of the print was considered an important part of the creative process by the designer, allowing for innovations such as dye applied directly to the screen with a brush, rather than with a conventional squeegee.

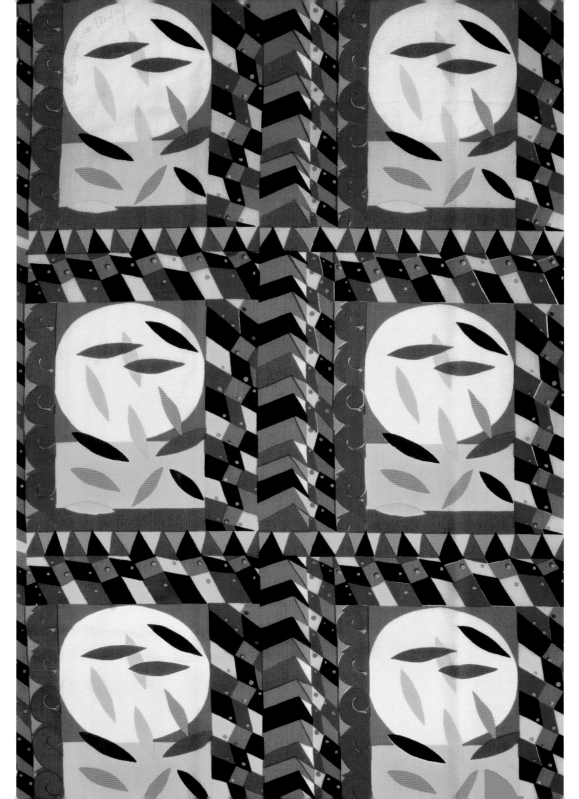

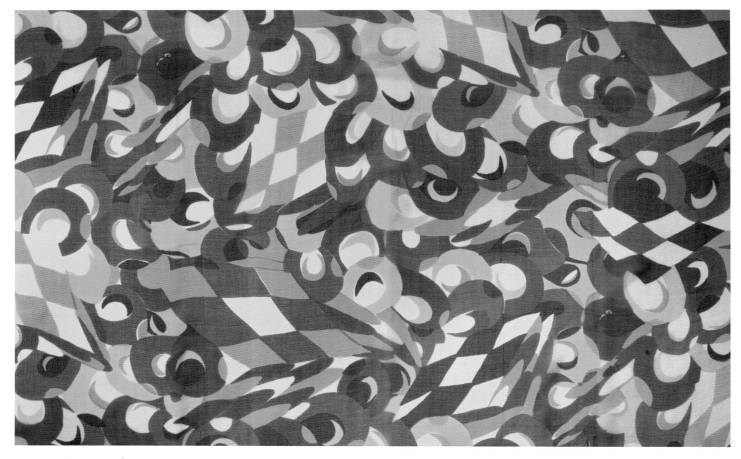

Above and left: This print design by Georgina von Etzdorf, *Paradise*, features a typically cleverly disguised repeat system.

Right: Brightly coloured blooms flourish on a dark background in this design, *Poppy*, from an original watercolour painting by Georgina von Etzdorf.

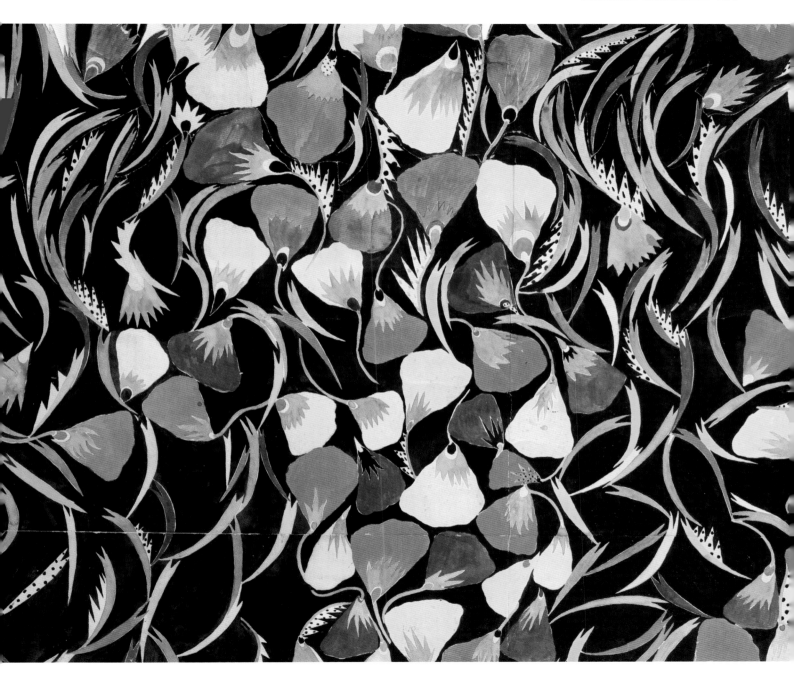

BIBLIOGRAPHY

Breward, Christopher. *The Culture of Fashion: A New History of Fashionable Dress.* Manchester University Press, Manchester, 1995
Breward, Christopher. *Fashion.* Oxford University Press, Oxford, 2003
Coleridge, Nicholas. *The Fashion Conspiracy: A Remarkable Journey through the Empires of Fashion.* William Heinemann Ltd, London, 1988
Jackson, Leslie. *20th-Century Pattern Design: Textile and Wallpaper Pioneers.* Mitchell Beazley, London, 2002
Kelley, Kitty. *Nancy Reagan: the Unauthorized Biography.* Bantam Press, London, 1991
Kennedy, Shirley. *Pucci: A Renaissance in Fashion.* Abbeville, New York, 1991
Laver, James. *Costume and Fashion: A Concise History.* Thames and Hudson, London, 1969
Littman, Helen. *English Eccentrics: the Textile Designs of Helen Littman.* Phaidon, London, 1992
McDermott, Catherine. *Street Style: British Design in the 80s.* Rizzoli International Publications, New York, 1987
Quinn, Bradley. *Techno Fashion.* Berg, 2002
Thakara, John ed. *New British Design.* Thames and Hudson, London, 1986
York, Peter. *Modern Times.* Heinemann, London, 1984
Yusuf Nilgin. *Georgina von Etzdorf: Sensuality, Art and Fabric.* Thames and Hudson, London 1998

INDEX

ACKNOWLEDGEMENTS

I would especially like to thank Allan Hutchings for his brilliant photography. Thanks to Tina Persaud, Nicola Birtwisle, Lee-May Lim and all at Anova Books; and Anita Corbin (www.corbinogradystudio.co.uk), Anna Buruma of Liberty plc, Professor Caroline Cox, Fia Palmgren at Tio-Gruppen, Fraser Taylor of The Cloth, Georgina von Etzdorf; Jimmy Docherty, Bridget Simcock, Helen David of English Eccentrics, Jenny Hoon, John Angus, Jonathan Postal, Natalie Gibson, Nicole and Phillip de Leon of Alexander Henry Fabrics, Pam Hemmings, Patrick Young of Vintage Modes at Grays Antique Market, Snake Lane Graphics, Sue Timney of Timney Fowler and Val Furphy and Ian Simpson of design studio Furphy Simpson; and, as always, my daughter Emily.

PICTURE CREDITS